Roman Vishniac

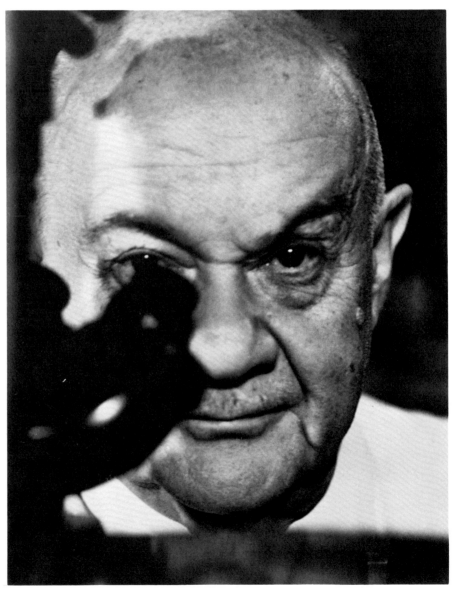

Roman Vishniac, 1966
by Craig Fisher

ICP Library of Photographers

Roman Vishniac

GROSSMAN PUBLISHERS
A Division of The Viking Press
New York 1974

ICP LIBRARY OF PHOTOGRAPHERS

Series Editor
CORNELL CAPA

Series Associate Editor
BHUPENDRA KARIA

ICP—the International Fund for Concerned Photography, Inc.—is a nonprofit educational organization. Established in 1966 in memory of Werner Bischof, Robert Capa, and David Seymour—"Chim"—ICP seeks to encourage and assist photographers of all ages and nationalities who are vitally concerned with their world and times. It aims not only to find and help new talent but also to uncover and preserve forgotten archives, and to present such work to the public. Address: 275 Fifth Avenue, New York, N.Y. 10016.

Vol. 6: ROMAN VISHNIAC

Editors
CORNELL CAPA
BHUPENDRA KARIA

Editorial Consultants
MICHAEL EDELSON
YVONNE KALMUS
ROBERT SAGALYN
SHEILA TURNER
DON UNDERWOOD
EDITH VISHNIAC
ENID S. WINSLOW

Design
ARNOLD SKOLNICK

ACKNOWLEDGMENTS

Our deep appreciation and thanks to Eugene Kinkead and *The New Yorker* for their permission to reproduce portions of "The Tiny Landscape." Copyright © 1955 by Eugene Kinkead.

Contents

Renowned in academic, scientific and artistic circles, Dr. Roman Vishniac has been a passionate and compassionate observer of life for most of his 76 years. As one of the world's foremost photographers of microscopic life, his contribution to our understanding of the relationship of nature, man and art through his work in still photographs and films is without parallel. His photographs of Jewish communities of Eastern Europe, made in 1938 on the eve of World War II, constitute the last pictorial record of a unique world which vanished only one year later. As a man, a humanist, and a photographer, Roman Vishniac wondrously fulfills the Lewis Hine definition of what we mean by a concerned photographer—"Things to be appreciated . . . things to be corrected." Roman Vishniac respects life and men.

Cornell Capa

Vishniac came back from his trips to Eastern Europe in the nineteen-thirties with a collection of photographs that has become an important historical document, for it gives a last minute look at the human beings he photographed just before the fury of Nazi brutality exterminated them. Vishniac took with him on this self-imposed assignment — besides this or that kind of camera and film — a rare depth of understanding and a native son's warmth and love for his people. The resulting photographs are among photography's finest documents of a time and place.

Edward Steichen

The Tiny Landscape

Eugene Kinkead

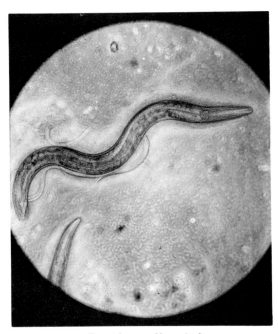

Roundworm Nematode

An earlier version of this article appeared in two parts in *The New Yorker*, July 2 and July 9, 1955. The article in its present form is the result of abridgment and revision made by the author in 1973.

These days Dr. Roman Vishniac does what he has always done. He leads a busy, variegated life. Now a gentle, stockily built grandfather of seventy-six, who holds a medical degree and Ph.D. in zoology and who has also made an exhaustive study of Oriental art, he spends his time energetically writing, teaching, lecturing, and photographing. But among this battery of pursuits he is probably best known for the last, especially his photomicrography. These glimpses into the tiny landscape that lies below the reach of the unaided human eye are considered by connoisseurs to be the finest ever put on film.

Vishniac made probably the youngest start of any practitioner in that field. He was a long-haired, sailor-suited child of seven when he took his first photomicrograph, in Russia, the country of his birth. His subject was a section of a cockroach's leg, and the result was not bad. Although his microscope could magnify an object no more than a hundred and fifty times and his camera was of the simple, single-lens type, supported on a pile of books, the picture he took revealed rather clearly the more prominent of the muscles that have aided the cockroach, that remarkably cosmopolitan insect, in eluding its enemies ever since its emergence in the Paleozoic era, some two hundred and fifty million years ago. The scene of Vishniac's operations was his bedroom in his family's Moscow apartment. The Vishniacs were well-to-do in those days, and their apartment was a large and comfortable one in a substantial, four-story brick building, at No. 13 Kiselny Pereulok, that had an elevator and central heating. The building has since been remodeled and made part of the notorious Lubianka Prison of the Communist secret police. "It's the most horrible spot in Moscow now," Vishniac said recently, "but it wasn't then." Vishniac remembers his room in the apartment as an extremely happy place. It was crowded with plants growing in pots, goldfish swimming in aquariums, lizards crawling around in terrariums, and, occasionally, a mammal or

6

two, such as a rabbit or a guinea pig, loping about in a cage. "To me, the prettiest parts of the room were always those where there was a living plant or animal," Vishniac recalled not long ago. "I was fortunate in having many living things that I could turn to, as a jeweler turns to his jewels." He may have been thinking of his maternal grandmother when he made this remark, for she was the wife of a diamond dealer in St. Petersburg, and it was she who gave him his first microscope, on his seventh birthday. With it came three slides—of plant, animal, and mineral materials—and he soon made others, from dead insects, the fur and scales of his pets, and the leaves, stems, flowers, and pollen of his plants. Before long he was studying everything possible under his microscope, particularly living organisms. "I was discovering things," he says. "I already had a camera, and its lens fitted so snugly over the eye-piece of my new microscope that it almost seemed it must have been designed that way. And that cockroach's leg showed up so clearly when magnified with a bright light that I felt sure it would make a good picture—better than some I took outdoors on cloudy days, at any rate. Well, it did. I didn't realize then, of course, that people had been taking pictures through microscopes since 1843." The boy was nine when he got his first glimpse of protozoa, in a drop of water from his goldfish bowl, and the occasion is still clear in his memory, interwoven with the protective warmth of his room, the sunlight piercing the white curtains, and the soothingly familiar cries of Moscow's street vendors.

Each year in the middle of May a momentous event occurred in young Vishniac's life—the moving of the family to a *dacha*, or country villa, a few miles outside Moscow, to escape the city's summer heat. On the morning of the move, two horse-drawn wagons would pull up before the apartment house, and mountains of paraphernalia needed for such a migration would be loaded aboard. The cook and the chambermaid would be strategically stationed aloft to guard the pos-

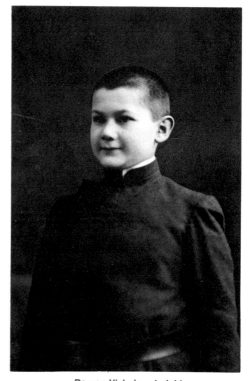

Roman Vishniac at eight
Moscow, 1905

7

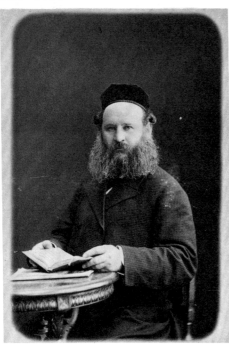

Vishniac's grandparents,
Beila and Wolf Vishniac, c. 1887

sessions on the journey, and the rest of the household would make the trip by horse tram. Country life was difficult for Vishniac's father; he commuted daily to the city on the lurching tram, and was often obliged to lug home large bundles of food at night. But for the others it was a leisurely round of pleasantly placid days among rolling, birch-covered hills. Young Vishniac, through his microscope, communed with nature. His country joys were very special, and very characteristic of the later Vishniac; the role of barefoot boy with cheek of tan was not for him. One day when he was eight, some older boys in the neighborhood took him fishing. The experience was traumatic. "I caught a fish," he says, still saddened by the memory. "A little shiner, four inches long. It was bleeding on the hook. My companions told me not to worry about it. There was nothing unusual about a fish bleeding on a hook, they said. But I knew that when *I* bled it was serious, so it must be serious when a fish bled, too. And what was I to do with the bleeding fish? The other boys told me to forget about it and give it to the cook for lunch. But no, no, I could not do such a dreadful thing. I found a pail and filled it with water and carried my fish home in it. I took it to my bedroom and tried all sorts of medicine. I found some sterile gauze—the kind my mother applied to my cuts —and tried to stop the bleeding. I remember even now how the fish stared at me with its big eyes that seemed to be asking, 'Why did you do this terrible thing to me?' Then my fish died, and I dug a grave for it in the garden. And I felt guilty. Horribly, horribly guilty."

Vishniac was born on August 19, 1897, in the *dacha* of his mother's parents—the diamond dealer and his wife—not far from St. Petersburg. His father, Solomon Vishniac, who was the son of one of the first Jews to be granted the legal right to live and work in Moscow, was Russia's leading manufacturer of umbrellas and parasols.

The comfort of the Vishniacs' life contrasted sharply with the life of most Russian Jews at

Cockroach leg

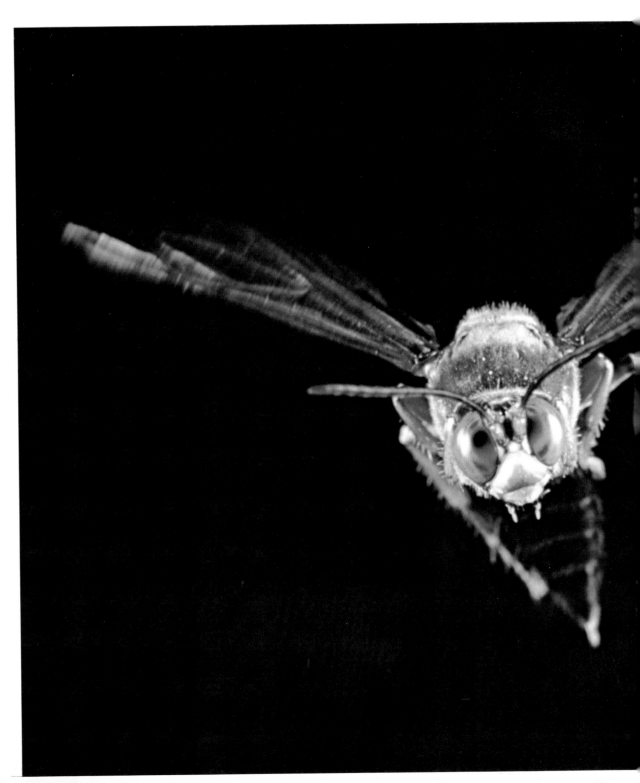

Cicada killer.
Photographed at 1/75,000th of a second

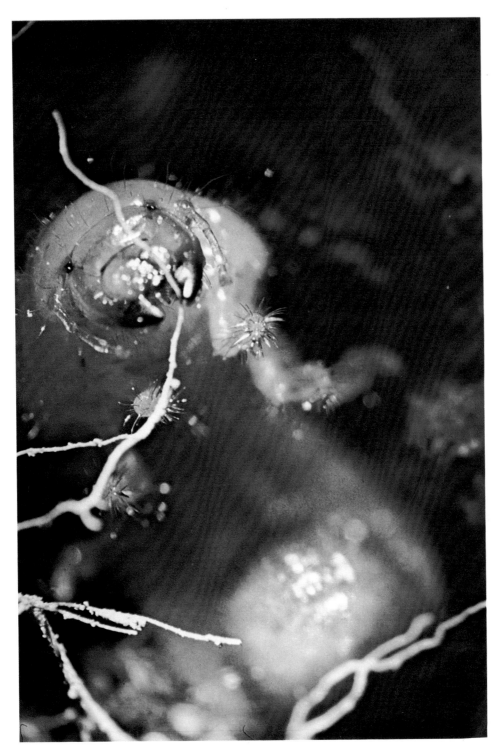

The grub of a Japanese beetle
cutting grass roots in the soil

that time. Moscow was about the only place where Jews could make a respectable living, but only a few were allowed to live and do business there. The police were constantly on the lookout for Jews who were in the city illegally, and those they caught they returned to their mean little villages in the provinces, where they were denied equal economic opportunity with other Russians. Jews illegally in Moscow were lucky indeed if they knew of a house in which they could safely spend the night, and the Vishniacs often had several guests of this sort for an evening. The police knew about it, but they made no trouble beyond presenting themselves at Solomon Vishniac's factory and demanding money, which was paid. The only sufferer from this hospitality was young Vishniac, who still recalls the fugitives with an almost morbid clarity. "They had a special kind of face, those people, a special kind of whisper, and a special kind of footstep," he says. "They were like hunted animals—a terrible thing to be. I can never forget them."

In 1914, at the start of the First World War, Vishniac entered Shanyavsky University, in Moscow, where he spent six years, specializing in biology and earning his doctorate in zoology. He did so well there that while he was still in his teens the university made him an assistant professor of biology. As a graduate student he did research in endocrinology under the tutelage of Nikolai Koltzoff, a famous physiochemist and protozoologist, and performed a pioneering experiment upon a curious little creature known as the axolotl. The axolotl, which makes its home in Mexican ponds, is one of the few existing organisms that can reproduce in an immature state; indeed, under ordinary conditions it never grows up at all but spends its entire life in the larval form—as a drab, newt-like creature some six inches long. If, however, the pond it is living in starts to dry up, the larval axolotl gradually loses its gills and develops lungs and legs, and eventually it walks out of what's left of the water as a fully developed salamander, changed not only

in shape but in name, for it is then known as an ambystoma. Encouraged by Koltzoff, Vishniac set about trying to find a way of changing the axolotl from an aquatic to a terrestrial animal by synthetic means. He had already observed that as the time approaches for the metamorphosis of a tadpole into a frog, the tadpole's thyroid gland enlarges, and it occurred to him that it might be interesting to try some thyroid on an axolotl. The surprised owner of a slaughterhouse was delighted to sell him a number of sheep thyroid glands, which Vishniac cut up and fed to several axolotls in a tank well-filled with water, in which stood a rock that protruded above the surface. On the sixth day of this diet, the axolotls, to his intense excitement, started to change, and presently they scrambled up on the rock as salamanders. These bred, and the females returned to the water to lay their eggs. The larvae from these eggs remained axolotls only until Vishniac fed them thyroid, too. The experiment was completed early in 1917, and Vishniac wanted to publish a paper on his findings, but the troubled military and political conditions of the country made that unfeasible right then. (He never did write it, because before long a Czechoslovakian scientist, after going independently over the same ground and achieving the same results, came out with his own paper on the subject.) The same conditions prompted him, while continuing his research at Shanyavsky University, to enroll in an abbreviated three-year course in medicine that the Russian government, hard-pressed for doctors at the front, was sponsoring at the University of Moscow.

Vishniac had been studying medicine for only a short time when the Russian Revolution broke out. At first the members of his family fared pretty well, and as long as Kerensky was in power some of his relatives even held important posts in the government. But after the Bolsheviks overthrew the government and Kerensky fled into exile, the fact that he had formerly favored the Vishniacs did them no good. Vishniac

himself, having no political or economic ties, was unmolested and went on with his studies, but in 1918 several members of his family, including his parents and his sister, decided that they had better leave the country. Traveling under pseudonyms, with a few jewels that represented the small fraction of their wealth that they had been able to get their hands on, the little band of would-be refugees headed for Constantinople. They stopped off in Kiev, and Vishniac joined them there to give them some money he had managed to scare up after their departure from Moscow. It was fortunate that he did, for, by acting in a most uncharacteristic way, he was responsible for their being able to make their escape. While they were still in Kiev, it bacame apparent that they would need safe-conduct passes to get them through the south of Russia. Disguising himself as a typical Bolshevik irregular simply by wearing crossed cartridge belts over a leather jacket and carrying a rifle, Vishniac herded his relatives into the local headquarters of the Cheka, as the present **KGB** was then known, and into a room where a number of officials were sitting at desks, signing the documents that enabled travelers to obtain passes. "Comrade, passes for these people!" Vishniac said at one desk after another, in a voice that surprised him by its sternness. And at one desk after another the required signature was forthcoming. The final official whose approval was needed was in an inner office, and as Vishniac addressed him, he had a feeling that his face was familiar. Back outside on the street, he looked at the man's signature. It was Trotsky's.

In 1920 Vishniac finished his studies at the University of Moscow and was awarded the degree of Doctor of Medicine, certified by a diploma that was embellished with pictures of Marx and Lenin. His relatives having meanwhile made their way from Constantinople up through Italy to Berlin, he decided to join them, since the new Russia seemed to him the last place in the world where a man with scholarly, scientific interests

It was easy to empty eggs, fill them with tar and throw them against Jewish storesigns . . . that would make it quite obvious that this store should not be making money for the Jews.

could settle down. Again disguised as a soldier—the safest and most effective masquerade in those tumultuous days—he proceeded to a point on the border that was directly across from the Latvian city of Reschitza, where he had a friend who he knew would help him. It was a well-guarded section of the frontier; Communist troops were stationed in hidden machine-gun emplacements that commanded a view of a half-mile strip of cleared land, set off by barbed wire, that marked the border, and at night the entire area could be instantly flooded by searchlights. Vishniac studied the layout for several days, until he felt he had a pretty fair idea of where the gun emplacements were located; then, two hours before dawn one morning, he made a dash for it. When he was halfway across the cleared strip, he was spotted. The lights flashed on, and the guns began to spatter bullets. As he ran, zig-zagging desperately, he found himself repeating the prayer that Jews utter when they believe they are about to die: "Hear, Oh Israel, the Lord Our God, the Lord is One." At last he crawled in unharmed among some trees on the other side of the border, and when the sun rose, he made his way without further trouble to his friend's house. Latvia had just won its independence and become a republic, and the new government was acting cheerfully unconcerned about who was a citizen and who wasn't; anyone living there at the moment could get a Latvian passport, and Vishniac had no trouble getting one. Then he joined his parents in Berlin. He remained a Latvian citizen until 1946, when he became an American.

Vishniac spent nineteen years in Berlin, living most of the time with his parents. He had been in Berlin only a few months when he married a girl from Riga—also a refugee—whom he had first met at the home of an uncle of his in Moscow. They had two children—a son, born in 1922, and a daughter, born four years later. In Berlin the Vishniacs lived in an extremely frugal manner; very little remained of the cash they had received for their jewels. Vishniac's father was in poor health and unable to work, so it was up to the retiring, scholarly son to support not only his own family but his parents and, for a while, his sister, too. Vishniac accepted the responsibility philosophically. At one time or another, with the help of fellow-expatriates who had successfully established themselves in Berlin, he got a job in a dairy-products store, in an insurance firm, in a real-estate office, in a type-writer shop, and in an automobile factory. He worked at all these jobs without distinction, and he compensated for the drudgery by devoting his evenings and weekends to a prodigious round of more congenial activities. He took a post-graduate course in Oriental art at the University of Berlin and completed the work necessary for a Ph.D. in that subject, although he never received the actual diploma because of some Nazi-fabricated red tape; with a number of other physicians, he carried on a program of biological research, personally specializing in endocrinology; he made a study of optics and the behavior of light, which ultimately enabled him to work out a system of his own for using polarized light to reveal the internal structure of living creatures under the microscope; he discovered he had a talent for both portrait and journalistic photography and employed it as a pleasant way of supplementing his skimpy income; and as a member of the Salamander Club, a national society of German naturalists, he was a frequent speaker at its meetings in Berlin.

This idyll began to disintegrate during the early thirties, owing to the rise of Hitler and anti-Semitism. A growing feeling of apprehension interfered with Vishniac's enjoyment of the contemplative scientific life, and he was unhappy as only a sensitive man can be who is confronted with violence he can't prevent or avoid. Once, on a trip downtown, he found himself in the middle of a demonstration against a Jewish-owned department store, an experience that temporarily paralyzed his vocal cords.

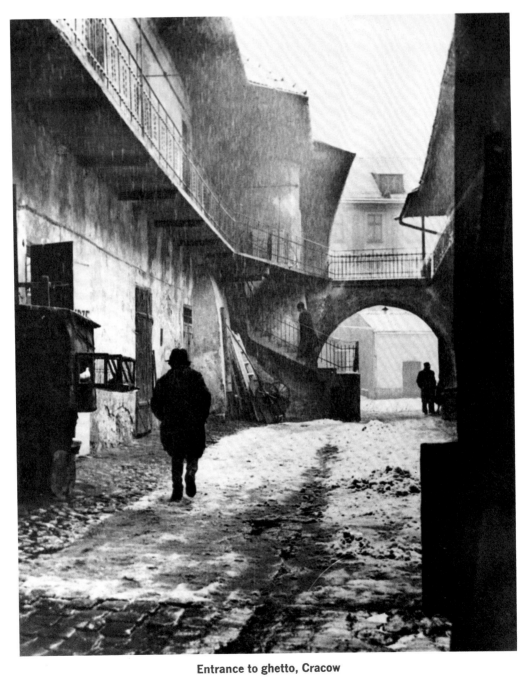

Entrance to ghetto, Cracow

Another time, the editor of a Nazi magazine, *Volk und Rasse*, approached him, not realizing that he was a Jew, and offered to pay him to make some photomicrographs showing how the blood of a pure Aryan differed from that of a Jew. When Vishniac replied that there was no difference whatever, the editor contemptuously turned his back on him. Such portents started Vishniac, in 1936, on one of the most extraordinary phases of his career—a series of expeditions, during which he covered five thousand miles in four years, to photograph the faces and the way of life of the Jews in Eastern Europe, whom Hitler had said he would destroy. "My friends assured me that Hitler's talk was sheer bombast," Vishniac recalls. "But I replied that he would not hesitate to exterminate those people when he got around to it. And who was there to defend them? I knew I could be of little help, but I decided that, as a Jew, it was my duty to my ancestors, who grew up among the very people who were being threatened, to preserve—in pictures, at least—a world that might soon cease to exist." Armed with a Leica for interiors and a Rolleiflex for exteriors, Vishniac journeyed through Poland, Lithuania, Latvia, Hungary, and Czechoslovakia, taking some five thousand pictures, always when his subjects were unaware that he was doing so. Posing as a salesman of fabrics to explain his presence in out-of-the-way places and the suitcases in which he concealed his equipment, he stayed at the houses of people he met en route and ate in the cheapest restaurants while traveling. Once, in the Czechoslovakian village of Dunajská Streda, a policeman spotted his cameras, and he was locked up in the Bratislava Prison for a month while the authorities took their time about examining his films to make sure that he had not been photographing military installations. Despite the thrifty way in which he and his family lived, they periodically ran out of money, and he would have to return to Berlin to take some run-of-the-mill job. As soon as he had saved enough to provide for his family's immediate needs and

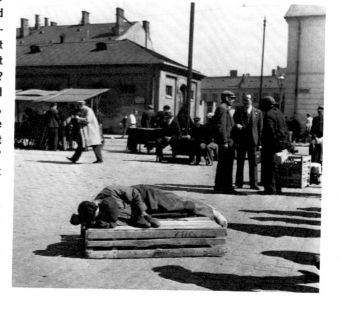

These were people
who made money the hardest way
—by carrying heavy loads;
loads heavy enough to compete
with trucks.

It was hot, it was heavy.
They were very tired and soon slept.
They had to guard their shoes,
because it was very tempting to steal shoes
from a sleeping Jew.

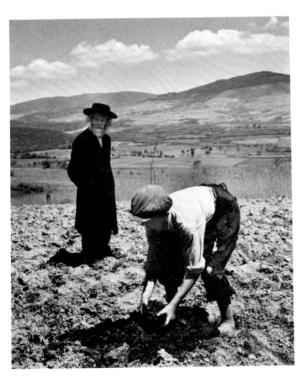

Manure distribution

for another of his sorties, he would start out again.

In 1947 a selection of the photographs Vishniac took in the course of these strangely dedicated wanderings was published here by Schocken Books under the not-all-inclusive title "Polish Jews." Subsidized by a man who was primarily interested in religion, it contained some thirty plates, stressing the spiritual side of the subjects' lives and, as Vishniac points out with some regret, it did not include any of the pictures he took to emphasize the economic struggle in which the Jews were engaged. Thirty-eight hundred copies of the book were sold, and Vishniac received one hundred and three dollars and thirty-seven cents in royalties. "It was not a best-seller," he said not long ago, with a smile. "In fact, one might almost call it a worst-seller." Nevertheless, the book had its admirers among discriminating critics. In discussing it, Edward Steichen, then director of the photography department of the Museum of Modern Art, once said, "Vishniac came back from his trips to Eastern Europe in the nineteen-thirties with a collection of photographs that has become an important historical document, for it gives us a last-minute look at the human beings he photographed just before the fury of Nazi brutality exterminated them. Vishniac took with him on this self-imposed assignment—besides this or that kind of camera and film—a rare depth of understanding and a native son's warmth and love for his people. The resulting photographs are among photography's finest documents of a time and place." One photograph among the thousands that are not included in "Polish Jews" also gained some recognition. It shows a small girl, with sad eyes and a wondering face, confined to her bed in the basement of an apartment building in the Warsaw ghetto because it is winter and her father is too poor to buy her shoes. The picture was exhibited at the International Photographic Exhibition in Lucerne, Switzerland, in 1952, and was awarded a prize as the most impressive of all the entries.

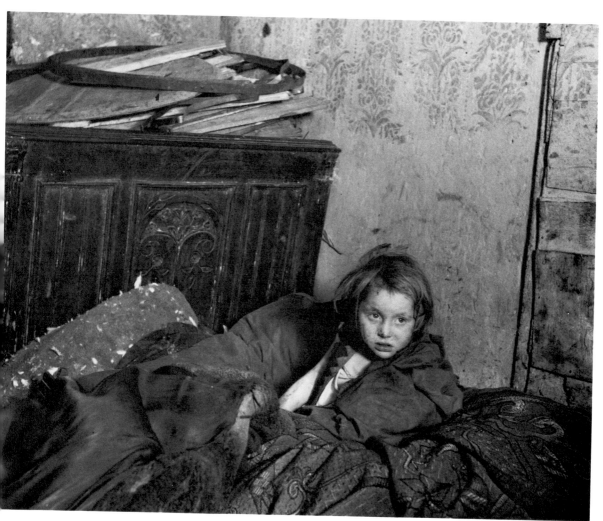

Munkacs, Hungary

Early in 1939, when anti-Semitism was at its height in Germany, Vishniac sent his wife and children to Sweden, where Mrs. Vishniac's parents had settled after fleeing from Riga, and then prepared to leave Berlin himself. In 1924 his sister had married a businessman from Odessa and moved to Paris, and her parents had recently joined her there, and now Vishniac felt that a family reunion was in order, especially since all the international signs pointed to the imminence of a war that might make reunions impossible for a long time. By the time he had wound up his affairs in Berlin, however, his parents had moved to Nice for the summer, so he joined them there, traveling without trouble on his Latvian passport and arriving in August, only two weeks before war was declared. Vishniac communicated with a friend of his in Washington who promised to do what he could to get him and his wife and children admitted to the United States, and then he and his parents moved to Annot, an obscure town in the Basses-Alpes, to await developments. But before anything definite came through from Washington, France fell, and the Pétain police arrested Vishniac as a stateless person, on the ground that Latvia had been absorbed by Russia and therefore no longer existed, and sent him to a concentration camp on the Loire. After three months Vishniac was released, through the efforts of Parisian representatives of the Latvian government-in-exile, and found that the way had been cleared for him and his wife and children to enter the United States. (His parents, who, although considered stateless, had not been arrested, preferred to remain in Europe.) Vishniac immediately got in touch with his wife in Sweden and arranged for her and the children to meet him in Lisbon. The four of them sailed from that port for New York in December 1940.

The Vishniacs landed here on December 31, with four hundred dollars to last them until they could get on their feet. Their first impressions of the city were grim. Although something of a linguist, being able to speak Russian, Yiddish, German, French, Polish, Slovakian, Ruthenian, and Italian, Vishniac knew no English. Somehow or other—his recollections of that chaotic time are hazy—he found a cheap furnished flat near Columbus Circle only a few hours after landing and installed his family in it. The next day, armed with a few likely addresses he had been given by American correspondents in Europe, he set out to look for work as a journalistic photographer, hoping to make himself understood in one of his eight languages. Unaware that it was New Year's Day, he tried several picture agencies and found them either closed or staffed by a handful of more or less inebriated employees, who gave him an amiable welcome but hadn't the slightest idea what he wanted. Their high spirits further confused and depressed him, and he trudged home that night with nothing but bad news to report. "For me, it was a time of distraction and fear," Vishniac has since said of his first winter in New York. "As I wandered through the streets, I felt lonely and weak and terror-stricken among all those rushing people—people of another continent, another world, a world that I feared, because I didn't think I could find a place in it. The people were all going so fast—their eyes bright as diamonds, their roots deep in the soil. I kept asking with my own eyes, 'Can I become one of you?' But there was no answer. I had been crushed three times—in Russia and in Germany and in France—and I was like a child. Only, I was not a child."

Vishniac's work was not entirely unknown in this country; the magazine *Friday*, which discontinued publication in 1941, had printed a famous picture of his showing the Nazi book-burning in front of the Reichstag, and a few other pictures he had taken in Germany had been published here. But when it came to getting a steady job, the language barrier appeared to be hopelessly against him, and in his despair he turned to freelance portrait photography as a means of making a living. His customers were

Amino

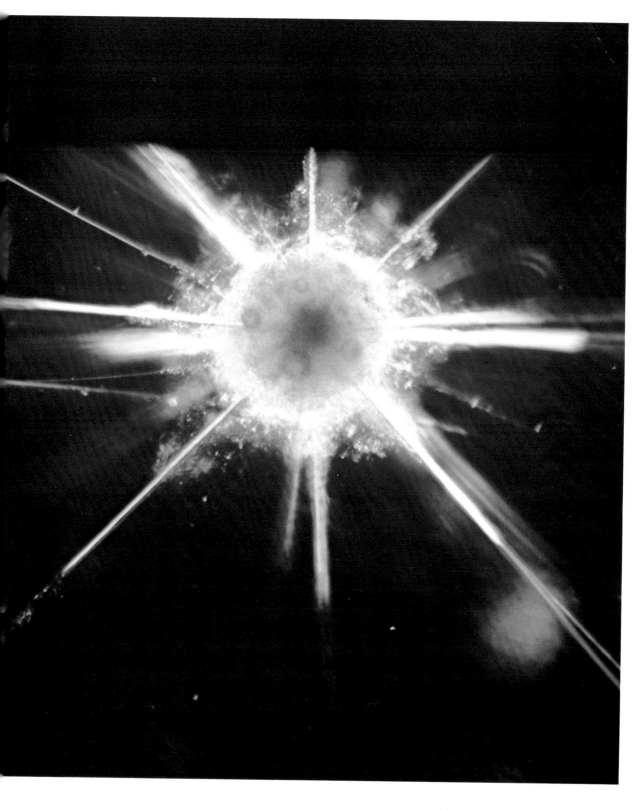

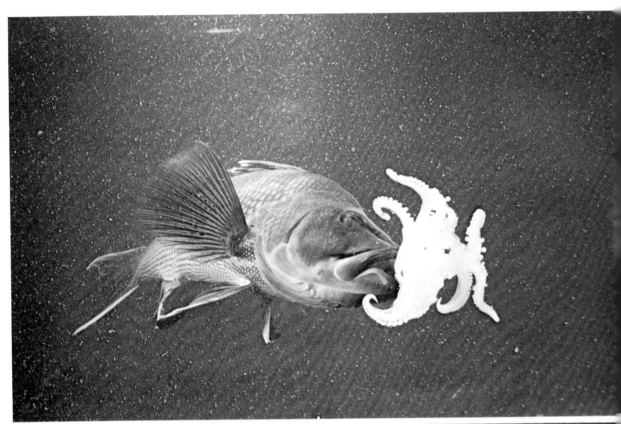

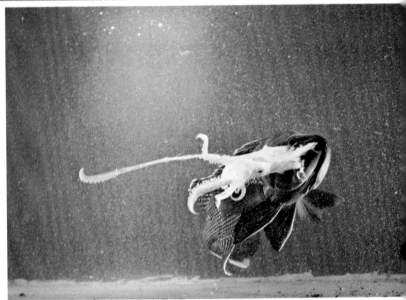

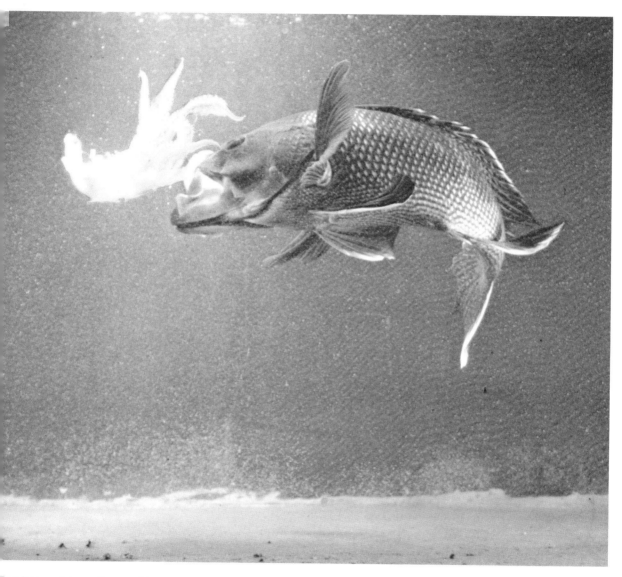

Sea bass seizing a live squid

Physalia—"Portuguese man-of-war"

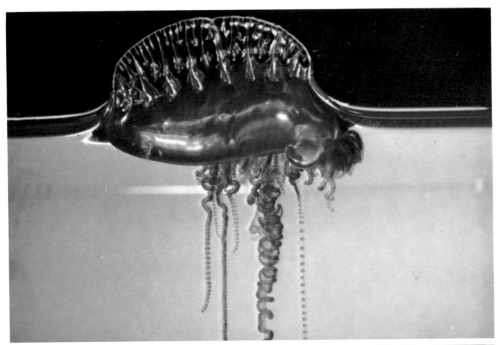

Vitamin

Pinus needle
magnified twenty times

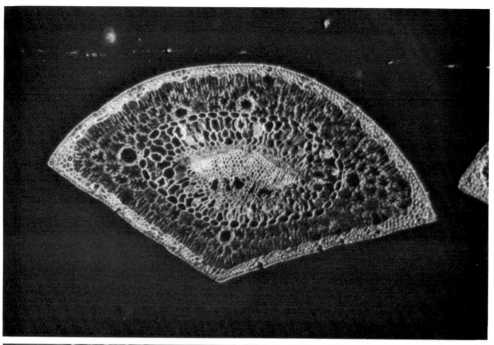

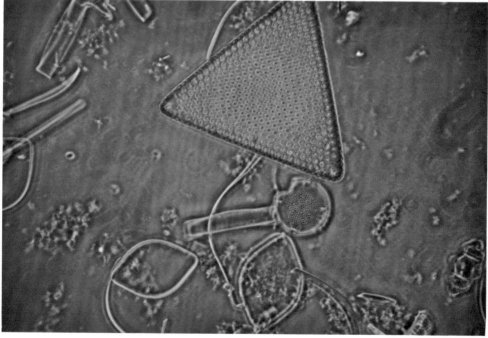

Fossil foram.
Six hundred million years old

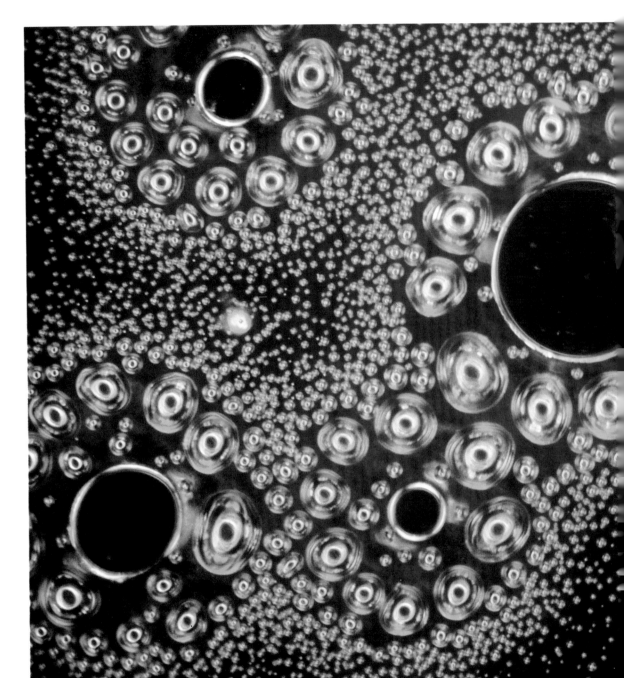

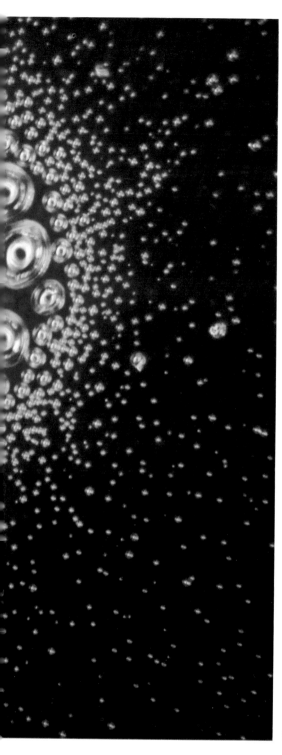

Cystine

"Nature, God,
or whatever you want to call the creator of
the universe comes through the micro-
scope clearly and strongly. Everything
made by human hands looks terrible under
magnification-crude, rough, and unsym-
metrical. But in nature, every bit of life is
lovely. And the more magnification we use,
the more details are brought out, perfectly
formed, like endless sets of boxes within
boxes."

Roman Vishniac

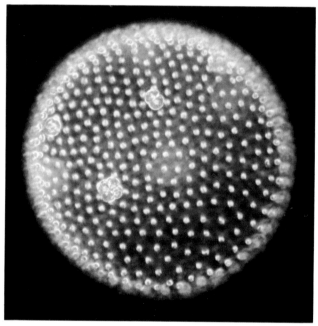

Volvox globator—colonial flagellate

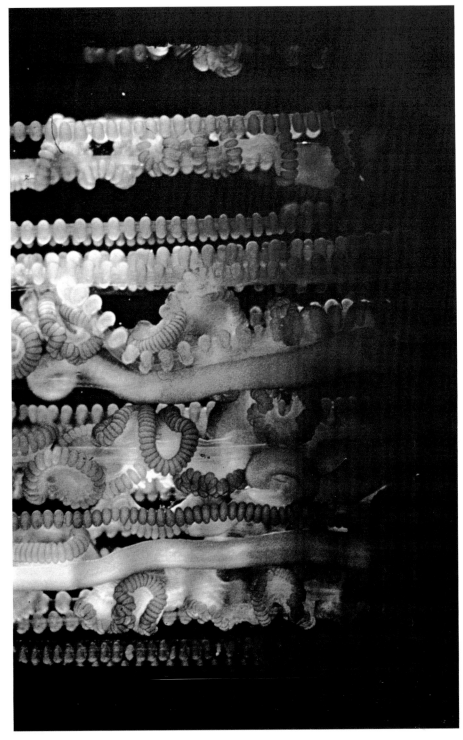

Gastrozooids

mostly members of the Russian colony here, many of whom he had known in Europe, and his studio was the single room that he and his family had moved to, on 72nd Street, between Broadway and Amsterdam. In spite of his wide Russian acquaintanceship, he did not prosper, and once, when business was even more slack than usual, he packed up a camera and set off, uninvited, for Princeton, with the idea of photographing Albert Einstein, whom he hoped to beguile into posing for him by passing along to him greetings from some friends both men had known in Berlin. Vishniac's reception in Einstein's study was not particularly warm. Einstein protested that he didn't want to pose, and as for the friends, he said he couldn't remember names and so didn't know who they were. Then, all at once, his voice trailed off, and he took a pad and pencil from his pocket and started to write. "It was a singular experience," Vishniac recalls. "An idea had suddenly come to him, and the room was filled with the movement of the great man's thought. I waited several minutes, and then, when I saw that he did not intend to say anything more to me and that he was off in a world of his own, I started taking pictures. And the background of those pictures was nothing but empty shelves. Unlike the studies of most scientists in Princeton, his had no books at all in it—he had nothing to work with except the pad, the pencil, some notes he had taken from his pocket, and a blackboard he had been using to figure out formulas. Not only was he not posing, he was not aware that I was there. It was an ideal situation for a portrait photographer. Here was the real, unposed personality of a genius. I was full of emotion, and very, very elated." Einstein later called one of the pictures Vishniac took that day his favorite portrait.

In 1942 he received some encouragement when he sold a series of photographs showing the nuptial dance of the May fly to *Nature Magazine* for twenty dollars, and this started him on a diligent crusade to interest the editors of other periodicals in nature pictures. He had only

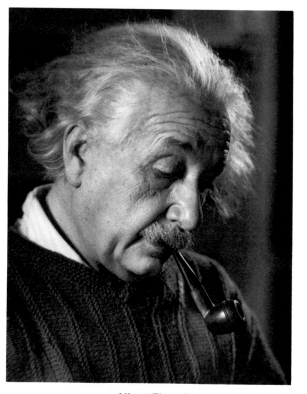

Albert Einstein

the sketchiest idea of what readers the various magazines were aimed at, so he called on editors pretty much at random, picking the names of about a dozen publications each day from the twelve-hundred-odd listed in the classified telephone directory. In this way he happened into the offices of *Vogue* one morning, and was saddened to find no editorial interest there in water scorpions or newts. Notwithstanding such setbacks, he kept at it and in 1950—his financial obligations having been considerably lessened by the fact that his daughter had married and his son had graduated from college—he gave up portrait photography, except for a special job now and then, and became a professional freelance photomicrographer, serving a rather heterogeneous clientele. "Vishniac was so obviously unsuccessful as a portrait photographer that I was sure he was doomed, but then he started producing his marvelous pictures of microscopic and near-microscopic animals," Philippe Halsman, a former president of the American Society of Magazine Photographers, said not long ago. "They're truly remarkable. Once, for seven hours I tried unsuccessfully to pose a dead fly on a replica of Salvador Dali's waxed mustache. Vishniac, on the other hand, working with live bugs that zoom all over the place, gets them in just the right poses. No one who hasn't tried it can comprehend the careful planning, the diabolical perseverance, and the incredible skill it takes to obtain the results he gets. The man is a special kind of genius."

Vishniac and his wife were amicably divorced in 1946; friends say that she never thought very highly of the large number of animals he insisted on keeping around the apartment, and that once the children were grown, the couple just drifted apart. In 1947 Vishniac returned to Germany for a brief visit. While there, he righted a headstone that the Nazis had overturned on the grave of an ancestor of his who had strayed from Russia and been buried in a Jewish cemetery in Wiesbaden; then he married a Berlin girl he had known before the war, and brought her back to New York with him. The present Mrs. Vishniac, who is blond, good-looking, cheerful, energetic, and some years younger than her husband, knows nothing about nature, or, for that matter, about the subject of photomicrography. But she does know about her husband's way of doing things, and in this respect she is so well informed that she is able to lay her hands in a minute on any one of his eighteen hundred pieces of microscope equipment or to produce almost instantly from his file of hundreds of thousands of negatives one of, say, an ambystoma that he took in 1949. (Vishniac on his own can never find what he wants when he wants it.) She has adapted herself admirably to the exigencies that arise from living in an apartment that is half zoo and laboratory and half home. On any given day her duties may include quartering a school of minnows in the bathtub, feeding and otherwise caring for six golden hamsters, and providing icebox space for a rack of test tubes full of bacterial cultures. If Vishniac suddenly announces that he is going to need his wife's pressure cooker to sterilize Petri dishes, she opens a can of corned beef. She is always prepared for the unexpected.

One summer, at Woods Hole, on Cape Cod, Mrs. Vishniac discovered that she possessed a theretofore unsuspected talent when she induced an eighteen-inch sea bass to pose for its portrait. Vishniac was working at the time in the laboratory of the United States Bureau of Fisheries—where he finds the atmosphere as convivial as some men find that of their favorite club—trying to get a picture of the sea bass in the act of seizing a live squid. This was a very difficult project, because sea bass will not ordinarily eat in the presence of human beings, and none had ever been known to take so much as a nibble while a photographer was within working distance. Sure enough, this sea bass would have nothing to do with any of the squid Vishniac offered it; each time he threw one in, the bass merely fanned its fins and eyed him coldly from the back of the

tank, while the squid scooted off in a cloud of ink. Two days passed, and then Mrs. Vishniac stopped by to see if she could help. She sat down on a folding chair in front of the tank as her husband retreated to the background, and began to murmur little blandishments to the sea bass in German. Before long the fish came forward and stared at her moving lips with what the Vishniacs interpreted as intense interest. Next Mrs. Vishniac ventured to dabble the fingers of her right hand in the water directly above the sea bass's head. The fish didn't seem to mind at all. Then she took a writhing squid, showed it to the fish through the glass, and dropped it into the water squarely in front of her husband's camera. Without hesitation the bass snatched up the squid, and Vishniac clicked his shutter. A moment later the other scientists on the premises were startled to hear shouts of "What a wife! What a wife!" reverberating through the halls of the Bureau of Fisheries building.

A while ago Vishniac received an assignment from a publisher to take a picture showing how the world looks when seen through the eye of an insect—an undertaking in which he received the willing assistance of Professor Talbot Waterman, a member of the Zoology Department at Yale and an authority on optics in the lower forms of life. The only previous photograph of this kind—a view of a church steeple as seen through a firefly's eye—had been made in 1897 by Dr. Siegmund Exner, an Austrian scientist, and it was a pretty good one, considering the rudimentary equipment he had to work with. Unlike the human eye, which operates in much the same way as a camera, with a single lens and with a single retina that corresponds to the camera's film, an insect's eye is a complex arrangement of many little eyes, called ommatidia, each with its own lens and retina. The task facing Vishniac and Waterman was to remove everything but the intricate system of lenses from an insect's eye

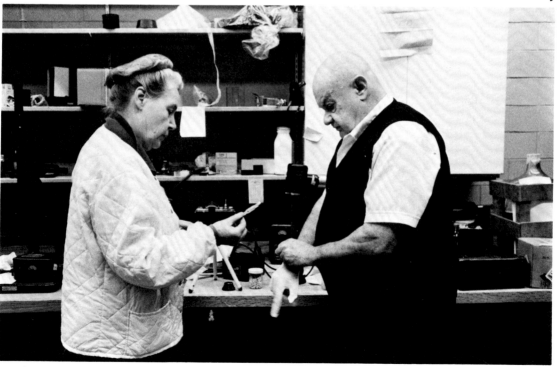

Dr. and Mrs. Roman Vishniac at home
by Kenneth Siegel

and record what came through it on a film that would take the place of the retinas. In accordance with his custom when embarking on any scientific undertaking, Vishniac did a vast amount of preliminary research on the subject. He secluded himself for two weeks in a room in the Osborne Zoological Laboratory, at Yale, and read everything he could find in the university's huge library relating to insect vision. "At such times one must forget the outside world for days on end," he says. "One must concentrate, concentrate, concentrate. Now and then one comes upon a difficult sentence that must be pondered for hours, since it may contain the formula on which all the rest of the author's work is based."

Once his research was completed, Vishniac called on Waterman and said, with a bow and a smile, "Until recently there was one leading authority on insect vision in New Haven. Now there are a pair of them." Then the two men set out to collect the scores of insects they knew they would need before they got the photograph they wanted. They combed the fields and woods near New Haven in a series of excursions that caused Waterman, who suffers from hay fever, no little physical distress. On one typical expedition, Waterman, Vishniac, and a couple of the former's students visited some meadows west of the city that were dotted with small ponds and seemed a likely place to find such large-eyed insects as robber flies or dragonflies. The party arrived at the scene in two automobiles, and Vishniac at once sprang out and began stalking resolutely through the swale, armed with a net and an insect-collecting bottle, followed closely by Waterman and the students. Twenty yards or so from the road, Vishniac flailed his net vigorously about him several times, and then examined his catch. "A mixed bag," he said. "Mostly little flies of many varieties." Gently, with fingers trained to a high degree of sensitivity by long hours of making fine adjustments at the microscope, he lifted some of the tiny creatures out of the net. Two of them were clinging to his forefinger. "A little wolf spider," he said of one. "So defenseless and harmless-looking now. But oh, under the microscope, what a fearsome creature, with fangs in which we know there is poison!" The other insect —a red aphid—moved slightly, brushing against the spider, which, fearsome fangs notwithstanding, hastily backed away. "When you stop to think of the nervous system it takes to make that little spider respond so swiftly and effectively, it is almost unbelievable," Vishniac said. "A comparable system in man would make him superhuman." The party moved on, and presently Vishniac, with a deft thrust of his net, snared a robber fly that had been perched on a daisy. "They always sit up high like that, the way hawks sit in trees, while waiting for their prey," he remarked as he popped the fly into his bottle. One of the students kicked over a flat rock, revealing a community of sow bugs, and Vishniac knelt down to examine them. "A very interesting and ancient animal," he said. "Extraordinary, in fact, for here we see a land animal that has gills. But even more fascinating—oh, almost incredible!—is the way humidity condenses around those gills to form moisture that is practically a microaquarium, for it contains flagellates, ciliates, and other fresh-water protozoa. Yes, it is indeed extraordinary. And here," Vishniac went on, turning his attention to a clump of grass, "is an obviously newly hatched Atlantis fritillary butterfly. See how helpless he is as he clings to the blade of grass. But soon, in this bright sunlight, his wings will dry and expand and mature and take on their typical pattern, all covered with a beautiful dust."

Waterman, who was beginning to sneeze, looked unenthusiastically at the butterfly. "Dust?" he murmured. "I wonder if it could be that."

Of all the insect eyes Waterman and Vishniac examined, those of the firefly seemed to them, as they evidently had to Exner, best suited for the task at hand. Fireflies' eyes are unusually well developed, because the insects use them to spot the lights of their fellow-fireflies, particularly in the mating season, since the male of the species flashes its light three times in quick succession and the female only twice. A firefly eye has a

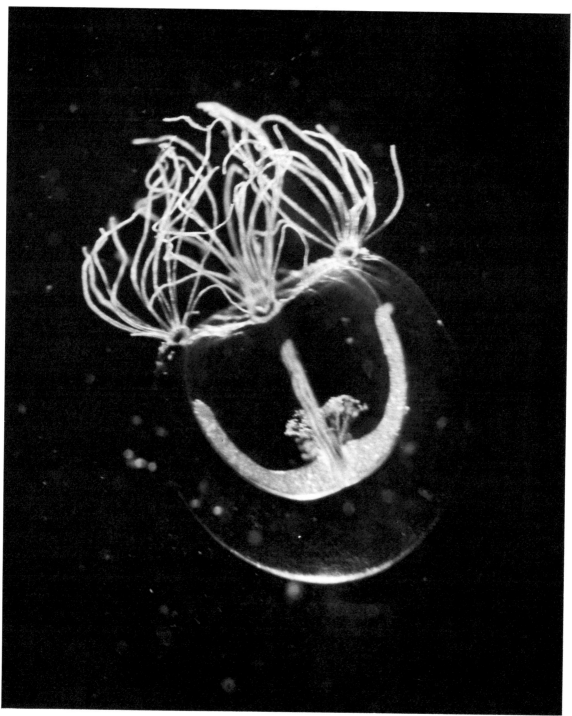

**Medusa phase of *Podocoryne carnea*
with twenty-four tentacles
and four radial canals**

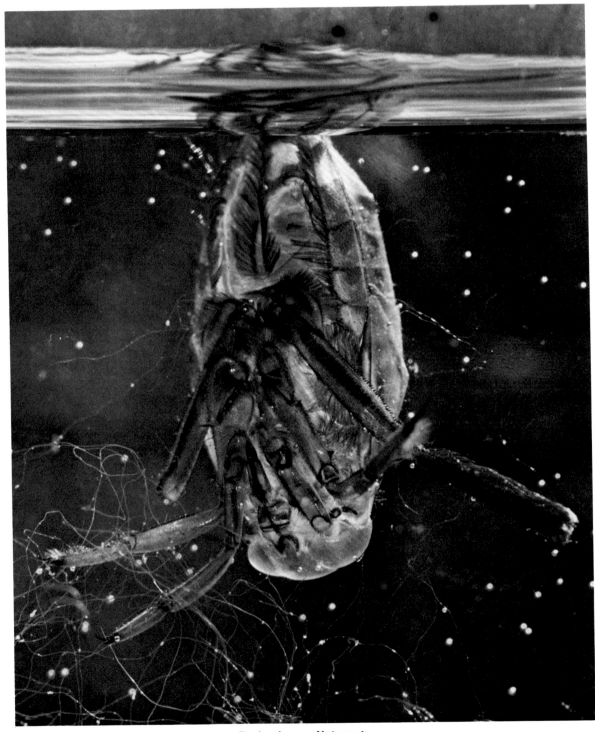

Backswimmer *Notonecta*

total of forty-six hundred ommatidia arranged on the surface of a hemisphere, a fortieth of an inch in diameter, of the hard, transparent, shell-like material that covers the bodies of most insects and is known as chitin. After three weeks of repeated failure, during which, Vishniac sadly admits, several dozen fireflies were obliged to give their lives, he succeeded in removing the forty-six hundred retinas from a firefly's eye, leaving only the outer shell, with its forty-six hundred lenses. He treated the shell with a clear solution of one part glycerine and two parts distilled water, in order to make it adhere to a microscope slide tilted horizontally, and then, by sighting through the instrument and manipulating its adjusters, he found that the point of focus of all the ommatidia was seventeen one-hundredths of a millimeter in back of the firefly's lens system. At a little before three o'clock on a sunny July afternoon he placed his microscope on the sill of a third-floor window of the Osborne Zoological Laboratory, adjusted it until the face of its objective was exactly seventeen one-hundredths of a millimeter from the outer shell of the eye, placed a camera against its eyepiece, and took a picture on color film of the nearby physics laboratory through the firefly's eye. The result, far clearer than Exner's pioneering effort, plainly shows not only the physics laboratory but a greenhouse in front of it. Both buildings look almost exactly as they did through Vishniac's eyes, except for a slight rounding of what he saw as straight lines.

Out on a field trip to collect specimens, Vishniac seems a fairly normal individual. Microorganisms can easily be scooped up in a jelly glass at the rim of any stagnant pond, and he catches insects in conventional nets and carries them in conventional bottles. But when he stalks insects to photograph them alive in their natural habitat, his movements seem to the uninitiated like those of a man possessed. In most photographs of insects, the subjects have been stunned with carbon dioxide, immobilized in action by a lethal spray of hot wax, or otherwise artificially posed. To Vishniac, these are not pictures at all; he scorns all photographs that do not portray real life. The difficulty is that for the kind of pictures he demands, the camera must be brought to within an inch and a half of the subject, and most photographers find insects too skittish to permit such familiarity. Vishniac, however, has developed an elaborate technique to overcome this handicap. Before setting out on a field trip, he spends several days on the grounds of the Bronx Botanical Garden, a great hangout for bugs, studying the habits of the particular insect he plans to photograph; every hour of photography, he frequently remarks, requires several preliminary hours of observation. "To get a fine picture of an insect, it is essential that the photographer know at all times what the insect is up to," he says. "The photographer must not think like a man. He must think like a bug. For instance, when I first tried to photograph a June bug, I imagined that, like most creatures in their natural state, he would be most active in the early morning, after a good night's sleep. But the early-morning pictures I took of the June bug were no good. Then observation made me see where I was wrong. Careful watching showed that the June bug's routine is to awaken slowly. He is still half asleep when he eats his breakfast. Then he communes with nature for a while. At last, long after I had been trying to snap him, he really wakes up and flies off briskly, like a Long Island banker taking a plane to Wall Street in midmorning. So now I photograph June bugs at around ten or eleven o'clock, and the pictures are full of true animation.

When Vishniac, at length, feels that he is sufficiently acquainted with an insect's habits to proceed with the actual photography, he makes a trip to some outlying suburban region, where the surroundings are less artificial than those of the Bronx. Upon arriving there, he lies down on the ground for an hour or more to saturate his clothing with the smells of the local vegetation, whiling away the time by rubbing his hands and face and equipment with grass and leaves. Then

he commences his stalking. Operating on the theory that insects are alarmed not by motion as such, for they see plenty of it whenever the grass and trees all about them sway before the wind, but only by movements to which they are unaccustomed, such as man's jerky way of walking, Vishniac proceeds through field and forest with the rhythmical, swooping grace of a ballet dancer—swiftly or slowly, depending on whether calm or breeze prevails. He is convinced that in

Copula of damselflies

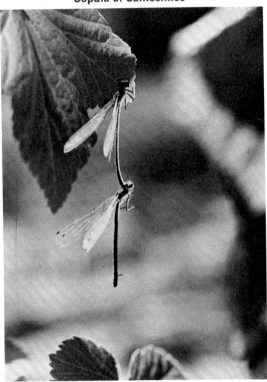

this way he lulls insects into a sense of security that permits him to draw much closer to them than a plodding pedestrian could hope to get. In moving from woods to a field, or vice versa, Vishniac repeats the hour-long ritual of acquiring the smells of his new environment. He has discovered that a man who has been wandering in a forest is as conspicuous to the insects in a meadow as he would be if his suit had just been taken out of mothballs.

Once he has thus unobtrusively entered a community of insects, Vishniac waits for his subjects to come and pose. When one appears, he glides to within a foot or so of it, sinks slowly to his knees, and, steadying his camera—a single-eye reflex with an extension tube that facilitates focusing and magnifying at close range—by holding it tight against his capacious chest, cautiously bends forward to gain a few more precious inches. Almost imperceptibly he swivels the camera against his chest until he has the insect in his finder; in the final moments before taking a picture he does not breathe. (He has trained himself to hold his breath for two minutes—a meager accomplishment, he feels, in view of the fact that Arab divers can do twice that.) Sometimes, just as he is about to click the shutter, the insect moves slightly, blurring the focus. Vishniac corrects this in one of two ways: If he has to alter the camera's position by only a millimeter or two, he resorts to what he calls a fine adjustment, which consists of simply inhaling or exhaling a trifle; if a greater shift is necessary, he makes a coarse adjustment, bending his body backward or forward from the hips, still with a barely detectable motion. Vishniac believes that next to fear an insect's strongest emotion is curiosity, and this seems to be borne out whenever one spots his camera. The suddenly interested bug advances on the instrument, touches it with its antennae, and then peers through the extension tube like an inquisitive small boy trying to see what's inside. When this happens, Vishniac gives up attempting to get the insect in focus, for he knows that once its curiosity has been roused, it will not be content to sit as a docile model again that day.

The average person has probably heard of protozoa, and may even at one time have seen some under a microscope, but the chances are that as he goes about his daily affairs he rarely gives them a thought. Vishniac, on the other hand, looks upon these minute, ubiquitous one-celled animals as friends and neighbors, deserving of civilized consideration and occupying a status equal to his own in the natural order of

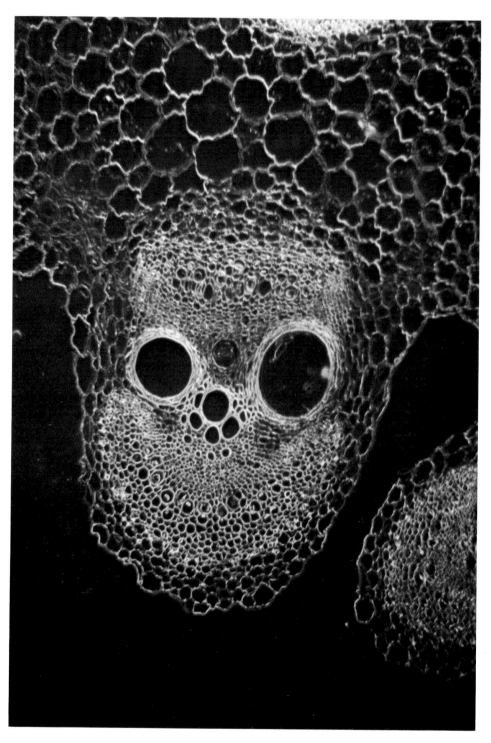

Ranunculus stem—crowfoot

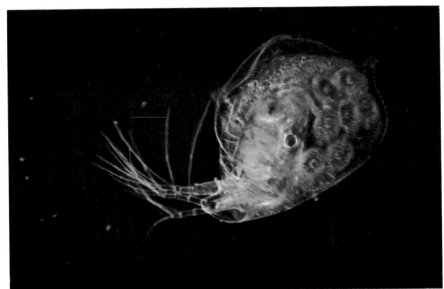

Water flea with young
in the brood pouch

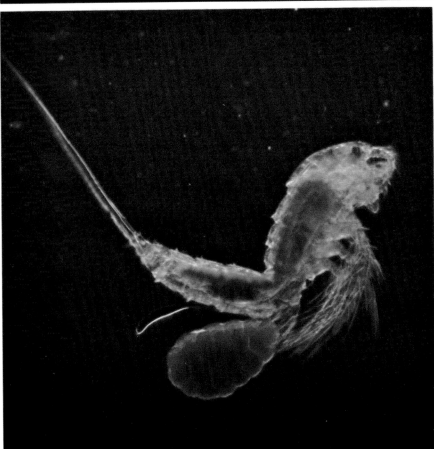

Female cyclops with egg sacs

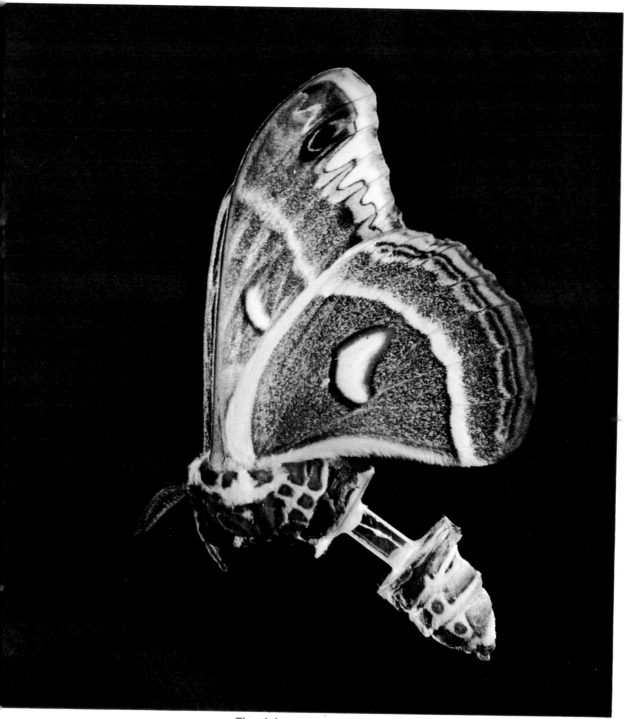

The abdomen of the *Cecropia*
is separated from the thorax and connected by a glass tube.
The tissue grows into the abdomen
and the *Cecropia* takes to the air again

things. Protozoa are believed to be the fore-runners of all animal life on the earth; some scientists estimate that the earliest forms of them must have come into being well over two billion years ago. This, in Vishniac's opinion, makes them worthy of man's profound respect. "A famous South African scientist once heard rumors that some fishermen in the Indian Ocean had hauled in a species of fish that lived a mere three hundred million years ago," he says. "Then, in 1952, a second of its kind was caught and the scientific world was all agog—and, my, what a fuss was made over it! Yet in any drainage ditch, in the scum on any pond, one can find certain species of protozoa that existed half a billion years ago. How does the history of man compare with this? It might chasten his pride if he would ponder the matter. *Homo sapiens*—with his puny fifty thousand years of history! Since the time of the first protozoa we know that nature has created more than eight hundred thousand species of animals—sponges and jelly-

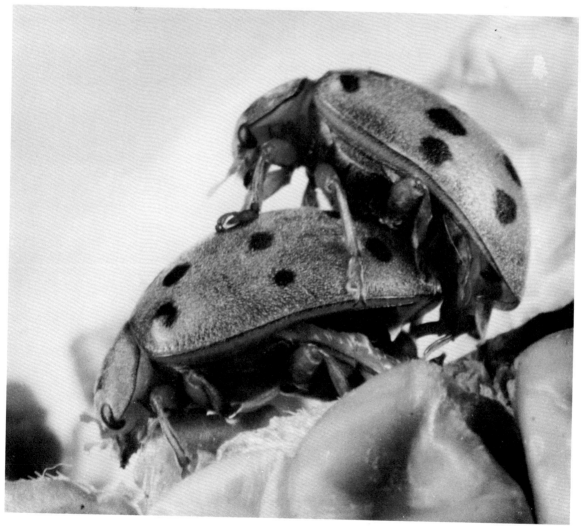

Copula of Mexican Bean Beetle

nino acid

fish, worms and spiders, whales and elephants. But few, if any, are more securely established than protozoa. Protozoa are not on the verge of extinction, like the European bison or the trumpeter swan. They are among the most successful animals in our midst."

Vishniac used to take pictures of human as well as unicellular subjects, but nowadays he devotes himself almost entirely to the photographing of objects so small that most people are barely aware of their existence. The microscopic world that he spends the greater part of his time contemplating is a strange one indeed to the uninitiated. Although separated from man's everyday world only by a set of lenses, it contains forms of animal and plant life wholly unlike anything that has ever been seen with the unaided eye. Vishniac's enthusiasm is further stimulated by the fact that commonplace objects that have no distinction at all in their unmagnified state are revealed in fascinating and undreamed-of detail under the microscope.

Vishniac feels that the microscope conveys intimations of divinity. "Nature, God, or whatever you want to call the creator of the universe comes through the microscope clearly and strongly," he once told a visitor to his laboratory. "Everything made by human hands looks terrible under magnification—crude, rough, and unsymmetrical. But in nature, every bit of life is lovely. And the more magnification we use, the more details are brought out, perfectly formed, like endless sets of boxes within boxes."

Vishniac reveres the microscope. He regards himself as the spiritual descendant of Anton van Leeuwenhoek, the famous seventeenth-century Dutch naturalist and microscopist.

The modern microscope is, of course, a considerably more complex instrument than anything known in Leeuwenhoek's day. The most powerful lenses available in the seventeenth century were capable of magnifying objects a mere two hundred and seventy times, while the ordinary present-day microscope can magnify

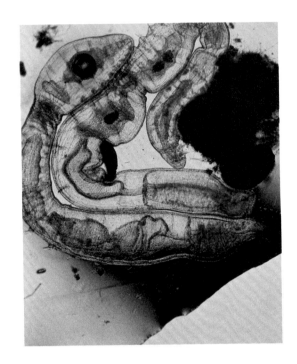

Aquatic Olygochaetes

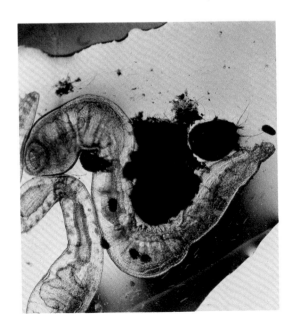

them twenty-four hundred times and the recently developed electron microscope up to five hundred thousand times.

For a photographer, Vishniac shows singularly little interest in cameras, and he does not seem to feel the pride in his collection of them that he does in his collection of microscopes. "Once a microscope makes a scene plain to the eye, any old box camera will do to snap the picture," he says. Actually, taking a photomicrograph of the kind Vishniac excels at is not as easy as that statement might lead one to suppose. For one thing, the camera must be mounted on a stand that holds it rigid over the eyepiece of the microscope. To be sure, that would be about all there is to it if Vishniac would content himself with slides of prepared specimens, but his insistence upon live casts of characters means that he, as well as the camera, must keep them under constant scrutiny, to make sure that the star performers don't wander out of focus or out of the field of vision entirely. Accordingly, he rigs up his microscope with a beam splitter—a device that breaks up the light as it emerges from the microscope's eyepiece, sending ninety percent of it, perhaps, to the camera and the remaining ten percent to an auxiliary eyepiece through which he monitors the scene.

People who work with microscopes are forever trying to overcome some of the exasperating quirks of the phenomenon of refraction. Refraction is the way light has of bending when it passes obliquely from one medium to another in which its velocity is different—from air to water, for example. "No matter how we try, though, there is always some light lost by refraction," Vishniac says. "To a microscopist, it is as certain as death and taxes, and not much more welcome."

Modern microscopes of the sort that Vishniac works with could effectively magnify an object many more times than they do if it were not for the problem of light. Light of ordinary wave lengths will not transmit the finer details that ultraviolet light, with its shorter wave lengths, will. He has spent thousands of hours over the past forty years trying to devise ways of using light more efficiently in both photography and microscopy, and one of the most important results of these labors—to him, at any rate—is a process he calls "colorization," which he uses as his own personal substitute for ultraviolet light. Essentially, colorization is a technique for bringing light to bear on the inner structure of the organism under examination in such a way as to reveal, in full color and in three-dimensional perspective, the crystal-like arrangement of the molecules that compose most, if not all, living tissues. "In trying to describe this process to a layman, one is bound to be guilty of oversimplification," Vishniac says. "Perhaps the best I can do is explain that ordinary light is made up of all the colors of the spectrum, and since these cancel each other out, ordinary light appears colorless. Another thing about ordinary light is that it vibrates in all directions, or planes, at once. Under most circumstances, this is a very fortunate thing, for it means that the rays of light are evenly diffused, but when ordinary light is used in sufficient quantity to penetrate the translucent interior of a microscopic organism, it obliterates the details with its dazzle. Unrestrained light assassinates microscopic structures. So we turn to polarized light, which is ordinary light that has been passed through a calcite prism to make it vibrate in one plane only. It is still colorless, but when it comes in contact with the crystal-like formations of the inner cell structure, it is broken down into its constituent wave paths—all with vibrations in different planes. Now I pass these colors through devices that speed up some wave lengths and slow down others, and what happens is that the detail and the color of the image that reaches the eye are greatly intensified, and the specimen's anatomy appears much as in a color X-ray."

Complicated though the mechanics of colorization undoubtedly are, the results that the inventor of the process obtains with it are master-

pieces of beautiful simplicity. The little water flea, for example, when colorized by Vishniac, emerges as a glowing golden globule with a darkly gleaming eye; an intricate blue-and-yellow muscular system, which controls its swimmerets as if they were the strings of a puppet; and a labyrinthine, mahogany-colored digestive tract— all in marked contrast to the flat, monochromic surface view of the animal under the customary microscopic illumination. As the muscles of colorized microorganisms flex and relax, they change color, in response to the changing conformation of the molecules composing them, and this suggests an entirely new approach to the mystery of how small animals—especially insects—perform their relatively prodigious feats of strength.

Vishniac performed one of his most delicate jobs of photomicrography some years ago when he made a pictorial record of a study undertaken by professors Brenton Lutz and George Fulton, of Boston University's Medical School, to ascertain the physiological consequences of disease and emboli in the blood of hamsters. Up to that time most experiments with the blood of human beings and other mammals had been performed after it had been removed from a body, living or dead; Lutz and Fulton were determined to observe and photograph the blood while it was still circulating in the living creature. After some investigation it was decided that the most advantageous spot in the hamster's anatomy for viewing its blood was the cheek pouch that is peculiar to the animal. Lutz and Fulton anesthetized their hamsters and then cut and folded back the tissue of the cheek pouches in such a way that they could be exposed directly under a microscope, in a little dish of optical glass that Vishniac had made specially for this work.

Vishniac worked in Boston several weeks, recording the changes wrought in hamsters' blood by the emboli that Lutz and Fulton artificially induced in them. One of his problems was to find his way back from day to day to some particular point in a hamster's cheek pouch—the site of an embolus, for example. He solved this by the use of lenses of increasing powers of magnification, with which he made a series of miniature aerial-photograph maps; the large veins were the highways and the small capillaries leading off them were the secondary roads. Thanks to this system, Vishniac never once during all his time in Boston lost his way in the microscopic wilderness of hamster cheek-pouch tissue.

On another occasion, Vishniac photographed a study of the injury and repair of blood vessels that was being conducted by Professor C. C. Speidel, chairman of the Department of Anatomy of the University of Virginia, in Charlottesville. Speidel used tadpoles in making his observations of this regenerative process, focusing his microscope on the translucent tissues of the tail, and Vishniac, after spending some time on the campus finding out what it was the professor wanted to record photographically, returned to New York to take the pictures in his apartment, which was better equipped for the job than the university laboratory.

"It was an inspiring sight," Vishniac has since said. "Perhaps several hundred red blood cells would have escaped from a severed capillary that had linked a small artery to a vein, and would be lying about in abnormal positions there in the wound. They were damaged and represented a danger of infection. It was vital that the stronger ones be saved and the weaker ones disposed of. And almost at once there would be several agents in the tadpole's tail intent on trying to salvage those red blood cells. Lymph vessels, for one thing, which are practically universal in living tissue and connect with the circulatory system. The nearest lymph vessel would send out a little sprout in the direction of the stranded blood cells. The sprout acted as a sort of life raft, and as it reached the cells, the stronger ones would rush to climb aboard and be carried back into the circulatory system. After this had gone on for a while, most of the hemorrhage would have cleared up, but then it would become

apparent that some of the red cells were beyond help—too weak to climb aboard. And now new agents would come rushing to the scene—microphagocytes, the white blood cells that assume the role of scavengers. They not only inhabit blood vessels but can go right through the vessels' walls —sometimes fast, sometimes slowly. The microscope showed all this. So the white blood cells, both small and large, would hasten as fast as they could to the trouble spot, the small ones coming in close and the large ones stopping and standing off at a distance while they sent out projections like arms. A large white cell would engulf a ruined red cell with its arms, draw it close, and digest it; some of them could handle as many as three or four. But the little white cells had a much harder time of it. Often one of them had to make several attempts before it succeeded in catching and holding on to so much as one red cell. After each failure it would move away, as if to try to make the red cell believe that it meant no harm, and then it would probe around, looking for a better approach. Finally, after perhaps five or six trials, it would succeed, and in this way the danger of infection was averted. And while all this was going on, the two ends of the severed capillary would have sealed themselves and there would be a new capillary forming to replace the old one. I have watched the growth of a new capillary many times. The artery and the vein each put out a tendril of endothelial cells, and the two tendrils grow toward each other. After several hours their ends join, forming a single connecting filament that before long becomes a full-fledged capillary, capable of carrying blood. Meanwhile, the two ends of the old, severed capillary shrivel and disappear. The process of regeneration in the tadpole has been completed."

Vishniac took seven hundred and fifty pictures of tadpoles for Speidel, and afterward returned every last one of his specimens from his bathtub to their pond in Putnam County. He is certain that the tadpoles' stay in his apartment —even the intervals they spent under knife and lens—did them no permanent harm, for by the time he released them they were starting to lose their scarred but still photogenic tails, indicating that, in accordance with their normal life cycle, they were about to become frogs.

Three times in the course of finding his way here from his native land, Vishniac barely eluded dictatorial regimes that were out to get him, escaping first from Russia, then from Germany, and finally from Nazi-dominated France, but he regards these adventures as rather tepid compared to a photomicrographic study he made in 1950 of the amoeba, the amorphous unicellular protozoan whose seemingly blind gropings have furnished thousands of elementary biology students with their first glimpse of microscopic life. He conducted this particular study in the Northern Regional Laboratory, in Peoria, Illinois, a well-known scientific institution that carries on a great deal of research involving bacteria, fungi, and amoebae. Vishniac chose the Peoria laboratory, rather than the one in his apartment, because he knew that it could keep him supplied with all the amoebae he wanted and with the most specialized equipment for examining them. The amoeba he finally settled on for his study was a soil-dwelling species of the order Acrasiales called *Dictyostelium discoideum Raper*. As is his habit before tackling any project, he prepared himself by reading everything available on the subject, and learned that although the Acrasiales were discovered in 1869, remarkably little attention had been paid to them since; only nine men in the world had considered them worth investigating, and even those had shown no more than a desultory interest in the subject.

Vishniac set up his photomicrographic equipment in one of the research rooms in the laboratory, procured some Petri dishes and a supply of *Dictyostelium discoideum Raper*, and peered at the amoebae through a microscope, awaiting developments. As hours and then days passed, he became electrified by what he saw. "The amoeba is a creature that is still just at

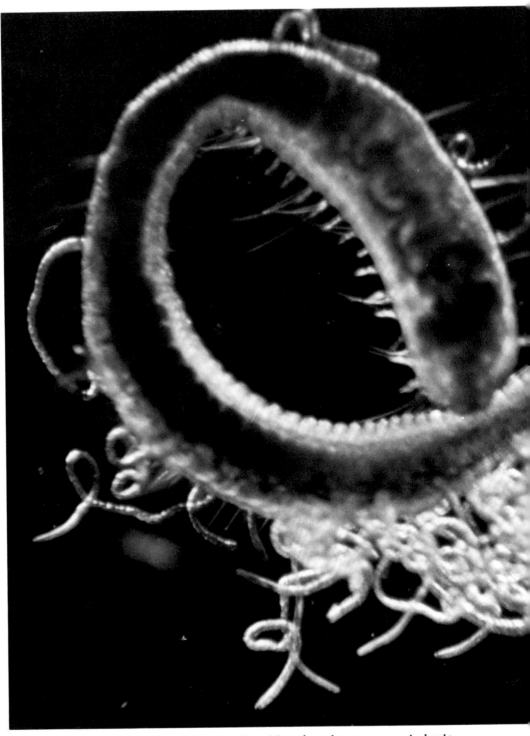

Cirratulus grandis—fringed marine worm, a polychaete

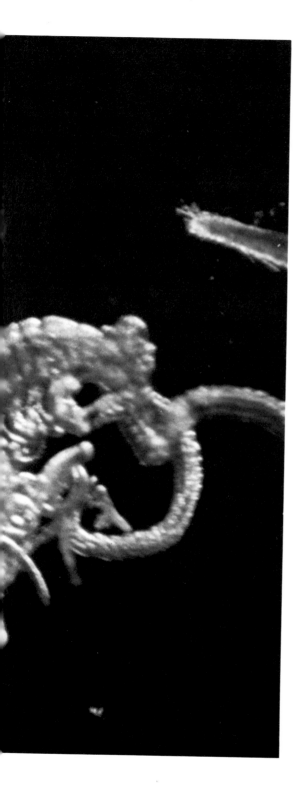

the beginning of the divergence of animal life from plant life," he says. "It is looked upon as very, very primitive by most scientists. Yet as I watched, I saw that on occasion it could become a social organism, capable of showing a likeness to a highly developed animal society. At first the scene consisted only of hundreds of amoebae among the millions of bacteria that were scattered about here and there in cultures over the vast microscopic spaces of the little Petri dish. As long as an amoeba had enough food, it showed no interest in its neighbors and lived independent of them, reproducing by its normal fashion of simply splitting in two—the biological process called binary fission, which is common among many so-called lower organisms. In times of scarcity, however, all this is changed. It becomes necessary to move to another place in search of food. But singly the amoeba is too small, too weak, to migrate. So what do the amoebae do? They start to move together. They stretch out hands, or so it seems, and in this way form thin lines. And then these lines of amoebae begin to move to a common assembly point. Why? What is the signal? Does some horn blow? What secret information does every amoeba suddenly possess? The need for this concerted action is evident, yet we do not believe that the amoeba has a brain. So what is it? We can only wonder. At the assembly point the amoebae build themselves up into a rounded stalk a thirty-second of an inch high. The microscope shows that they are still individual entities, but now they have fused themselves into a unit. Next the stalk falls over and starts to move horizontally, as perhaps a hundred thousand amoebae wiggle slowly forward. Onward the stalk goes, like a little ship on a high sea. What stimulates this forward movement is a mystery, but we can see that the most active part is at the head of the moving column. I tried transplanting the head of one column to its rear, but this did not stop the movement, for what had thus become the head pushed on. I tried analyzing the various parts of the moving column chemically,

but that produced no explanation, either. For thirty-six hours, assuming no food is found, the column wiggles forward, covering what is for amoebae the enormous distance of two inches. Then it stops, and a marvelous thing occurs. The column rears up to a height of a sixteenth of an inch from the bottom of the Petri dish and unfolds in a flower formation. The stalk is composed of amoebae that harden and die, but the amoebae that constitute the flower, which looks much like a chrysanthemum, produce spores—a form of reproduction not ordinarily associated with amoebae. Then the flower collapses, scattering the spores, which will before long become amoebae. No single amoeba survives the hegira, but there are now the new amoebae, and these will reproduce by fission until food in the new surroundings becomes scarce. Isn't this a dramatic tableau of the miracle of creation?"

The fact that Vishniac is a scientist as well as a photographer often proves helpful to him not only in his laboratory but in his dealings with other scientists. For example, he was once commissioned by a nonscientific publication to take some pictures of a number of experiments that Professor Carroll Williams, a youthful member of the Biology Department at Harvard, and several assistants were making to learn about the chemistry of metamorphosis in the Cecropia moth—a study for which, incidentally, Williams was singled out by the American Association for the Advancement of Science as the outstanding young scientist of 1950. When Vishniac called on Williams in Cambridge and asked for permission to take the photographs, the latter was hesitant; he was afraid that a photographer unfamiliar with the subject might botch the job. But Vishniac, feeling that he was on solid ground, persisted; he told Williams that thirty years earlier, in Europe, he himself had done considerable research on almost exactly the same subject—the only difference was that he had used another kind of moth. At this Williams relaxed and, after asking Vishniac a number of questions pertinent

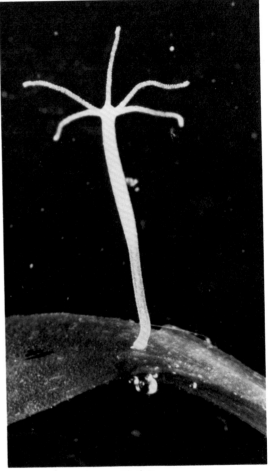

Hydra

to the metamorphosis of moths and receiving pertinent answers, he gave his consent to having the pictures taken.

Metamorphosis, as a matter of fact, is a subject toward which Vishniac feels an almost spiritual reverence. "It is a process of practically unbelievable change," he says. "Yes, in the short time it takes a single creature to develop, aeons in the development of the genus pass before our eyes. And for that we may thank hormones."

During the ten years that Williams and his assistants explored the metamorphosis of the Cecropia moth—an exceedingly tough customer, whose body in the larval and pupal stages can be cut into sections without extinguishing life in any of the parts—they ascertained that the changes are brought about by two hormones, one in the brain and the other in the thorax. Shortly before the pupa changes to a moth, the hormone in the brain is carried by the blood to the thorax, and there it stimulates the production of the second hormone, which circulates in the blood and reacts with the pupal tissues to bring about the actual metamorphosis. Williams discovered that the two hormones are so potent that when the glands producing them are implanted in the headless and limbless abdomen of a female pupa, they cause it to mature, attract a male, become fertilized, and lay eggs. Even Vishniac, adventurous though his imagination is, hesitates to speculate on what gruesome significance this phase of Williams' research may have for the future of the human race, but he nevertheless photographed the segment in the act of laying eggs, and cherishes the picture as a persuasive piece of evidence of the unquenchable quality of life. He also photographed the brain of a Cecropia pupa, cutting a hole in the opaque head and, with the aid of colorization, concentrating on the gland that produces the hormone destined to journey to the thorax. As he clicked the shutter he experienced a moment of true exultation, for this was the first time that the hormone gland of the brain of a living insect had ever been photographed.

Vishniac does much of his field photography in the vicinity of Croton Falls, in northern Westchester, where he has a cottage in which he spends his weekends during the spring and fall and much of his time in summer. His favorite out-of-town spot, however, is Woods Hole, and he does his best to arrange his affairs so that he can go up there for a month every summer. The Marine Biological Laboratory, which is another attraction of the place for him, has a collection of reference books on biology that is the most extensive one he knows of ("Where else would one be able to find a copy of Volume Two of *Archiv Biontologii*, printed in 1908, with Kirchhoff's paper on 'Augen der Pentameren Käfer' in it?"), and the fact that all the facilities for scientific research with which the community abounds are practically on the edge of a shoreline that is a rich source of a wide variety of specimens makes the setup ideal for him. At Woods Hole one evening in August, Vishniac found himself in a restless mood; the weather was sultry, and he suspected that he would be unable to get to sleep easily. Casting about for some photographic project with which to pass the time, he hit upon the idea of making a series of pictures recording the mating habits of the bristle worm, or Nereis, a bluish-green marine organism, an inch or two long, with red and orange spots. The female invariably dies while mating—the only instance of such a thing in nature, as far as Vishniac knows. Shortly after ten o'clock he set out on foot for a likely nearby tidal pool, wearing rubber boots and carrying a net, a pail in which to bring back specimens, and a flashlight, whose beam he hoped would attract some reproductively inclined quarry. Luck was with him; less than fifteen minutes after he waded out into the pool, a whole school of the worms swarmed about him, and he scooped them up in his net and lugged them back to the Marine Laboratory. Originally he had thought the trip to the pool might be enough to

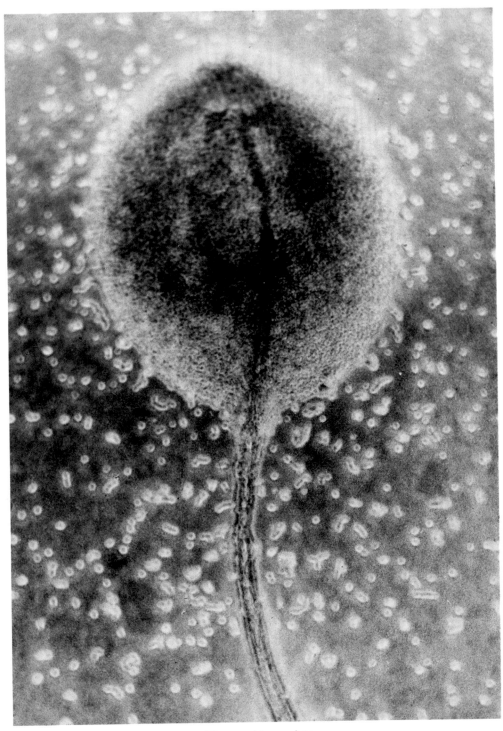

Slime mold amoebae

make him sleepy, in which case he would photograph the worms in the morning, but now he felt doubly keyed up and eager to get on with the job. He emptied the contents of the pail into a well-illuminated aquarium, adjusted his photographic apparatus, settled himself on a stool, and oblivious of the passing of time, worked on through the sticky summer night, studying and making pictures not only of the worms but of other organisms that had happened to land with them in his net. "Those tiny animals of the sea passed before my finder in a never ending procession," he said later. "There were the Ctenophores, looking like beautiful luminescent Japanese lanterns. And then some Sagittae (arrow worms), with their fearsome mandibles. Next came the Zoea—the larvae of crabs—and then the Megalopas—next stage—those creatures with such tremendous appetites. And now—now what do we see? We see the male bristle worms, circling in the light in a state of wild excitement. Then we see a female approaching, with her peculiar tapering movement. Now the males circle around and around the female, whirling madly, closer and closer. And then finally one reaches her, and in the moment of fertilization the female literally explodes, scattering the fertilized eggs in every direction. And then more males, and more females —over and over again this miracle of life and death occurred before my eyes. Nereides—even more lovely than their name! It was nearly dawn before I turned off the lights and started home."

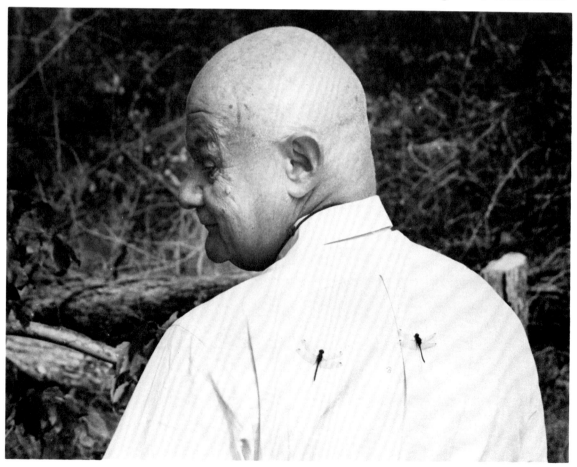

Roman Vishniac, 1972, with dragonfly friends

The Life
that Disappeared

I was born at the end of the last century
in Czarist Russia in a small town called Pavlovsk. That was many
years ago, but presumably everything is a long time ago and
a very short time ago. In Czarist Russia the life of the Jews was
very hard and later it became harder. I heard from the people
close to the Nazi administration that the Jewish problem must
be solved by killing the Jews, and when I asked how great is the
danger, they told me maybe it is not too great during peace, but
if the war will happen no Jews will survive. At this time they
would let the Jews go. The men asked, "Where is a visa available?" Dr. Wischnitzer of Hias answered, "I can get for you a
visa to Australia." "Australia . . . ? So far. . . ." And Dr. Wischnitzer answered, "Far? Far from where?" And then there was
silence because suddenly the places where the Jews lived for
hundreds and even more than one thousand years became nonexistent. And I thought maybe years and years after the killing,
maybe the Jews will be interested to hear of the life that disappeared, of the life that is no more, and I went from country to
country, from town to village and up in the mountains, where I
found the Jews in the Carpathians. . . . It was a very difficult
task. I was many times in prison, but I returned again and again
because I wanted to save the faces. They were all killed . . . all. . . .

Excerpted from the audio-visual presentation "The Life
that Disappeared: The Vanished World of the Shtetl,"
narrated by Dr. Roman Vishniac, edited by Sheila Turner,
and produced by the International Fund for Concerned
Photography, Inc., as part of "The Concerns of Roman
Vishniac" exhibition, 1971.

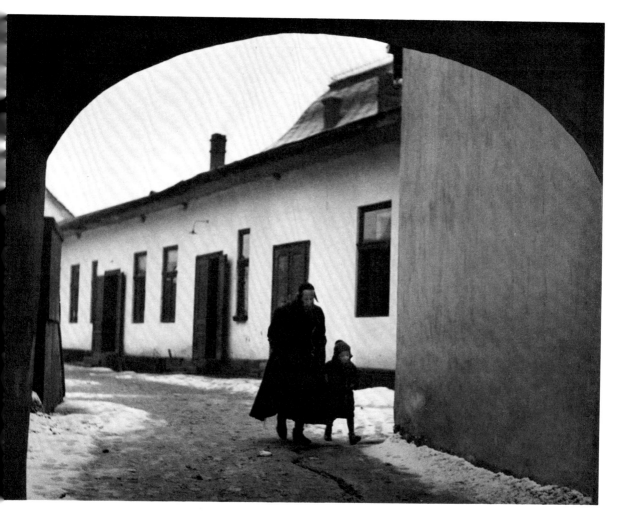

Father taking son to *cheder* (school), Munkacs

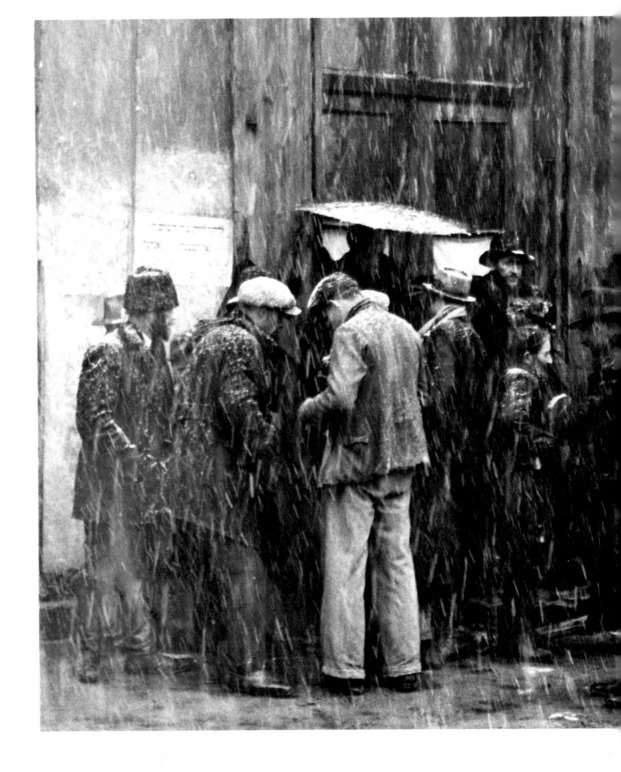

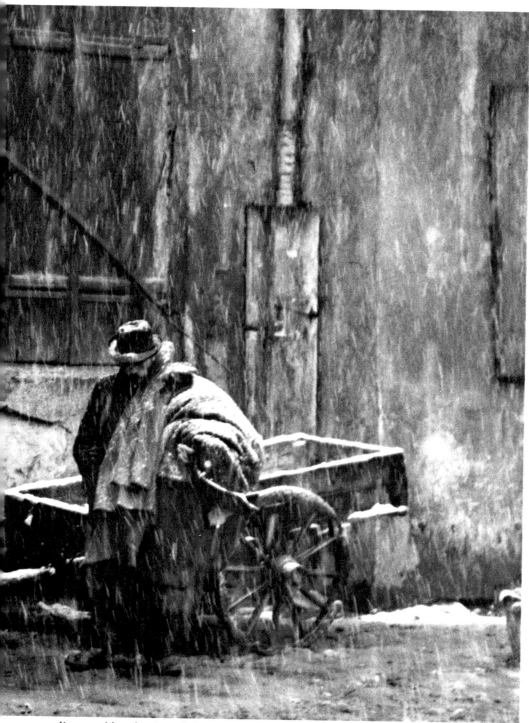

Cracow

It was cold and wet, and they were standing in the snow.
They had no hope. Only one thing gave joy . . . *Chanukah*
was coming. The great holiday. 1938 was the last *Chanukah*
of these people. The next year they were all arrested and
killed.

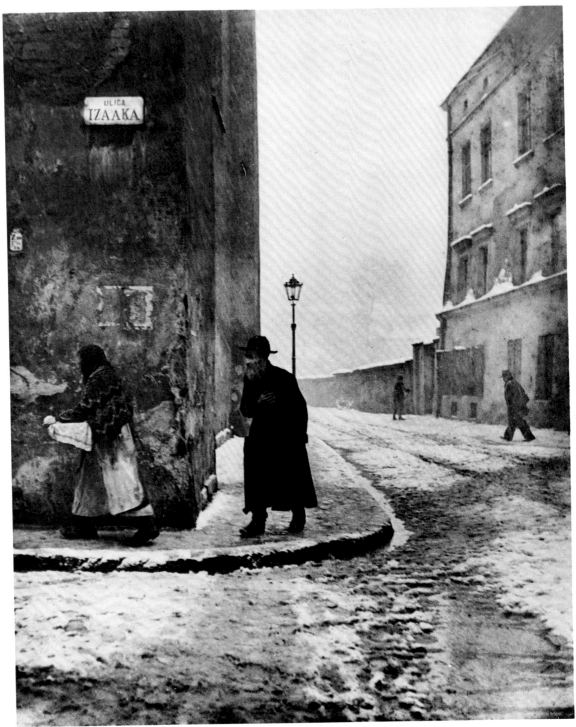

The street of Isaac

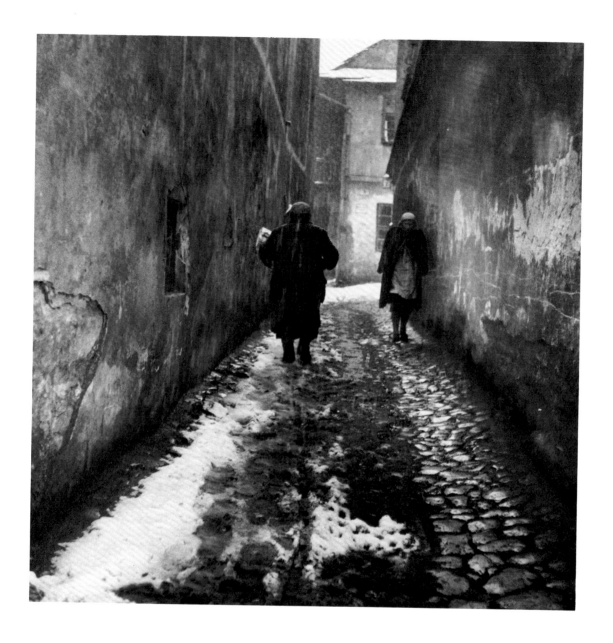

There were three streets
in the center of Jewish Cracow—Abraham, Isaac, and Jacob. Standing on the corner of Jacob Street I had the feeling that time had moved back to the fifteenth century. I was there again after the war, but the streets had different names. Only the buildings stood where they were before. Cracow was absolutely cleansed of the Jews—what the Nazis called *judenrein*. The Poles finished the job.

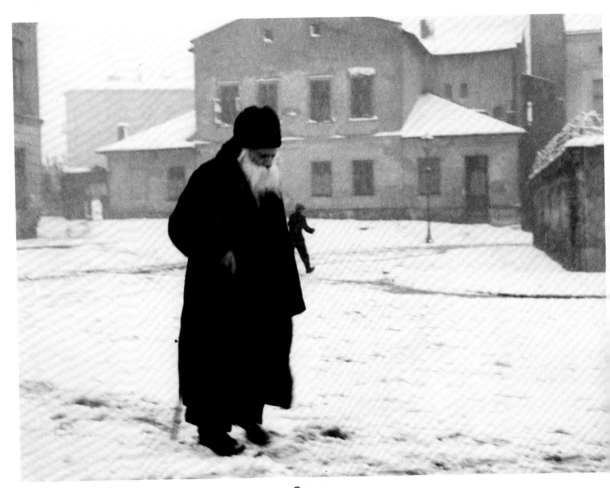

Cracow

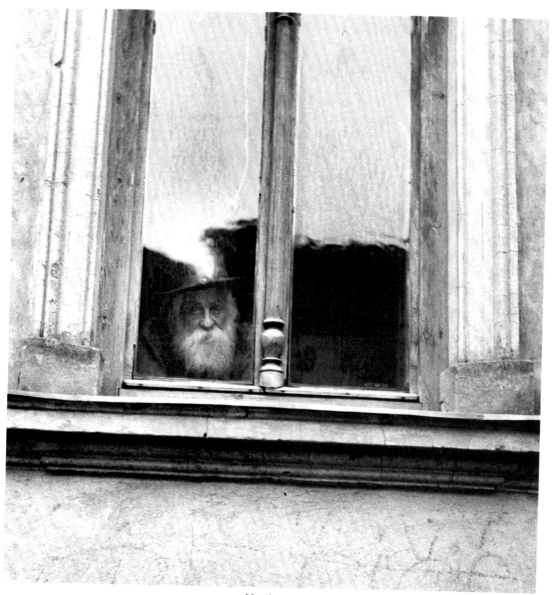

Munkacs

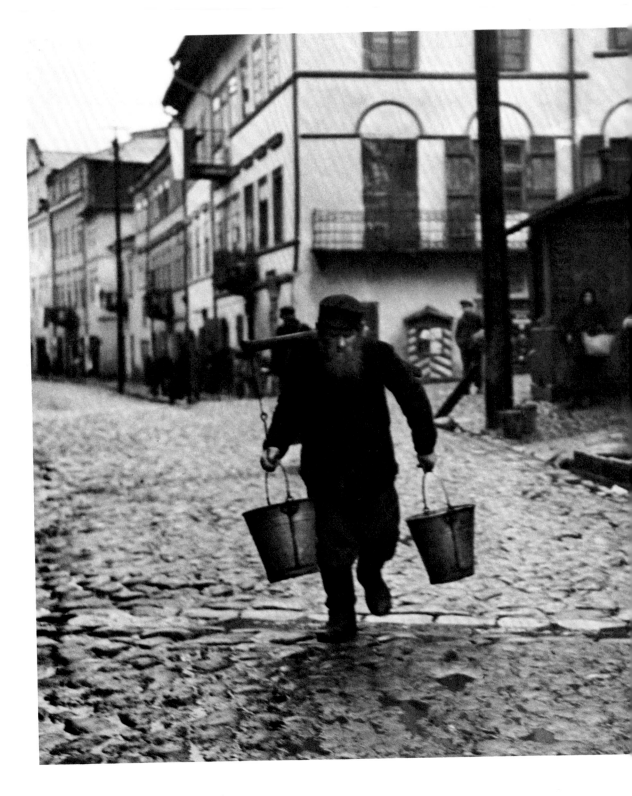

Lublin, Poland, 1938
In order to feed himself and his wife
this old man carried pails of water filled to the brim up four
flights of stairs from morning till evening. His wages were
so low that one could hardly buy a newspaper with the
proceeds.

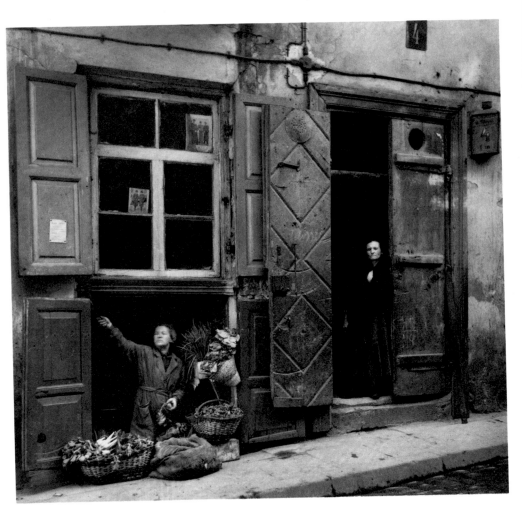

Vilna, Poland

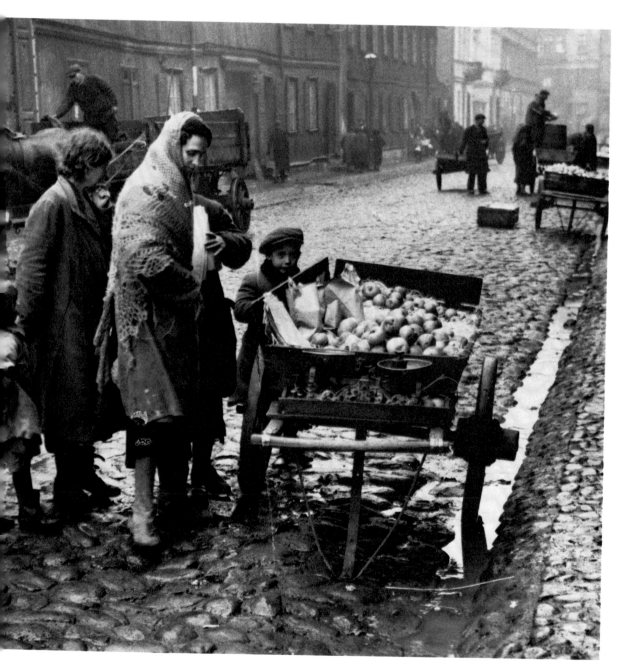

The Jewish street in Warsaw

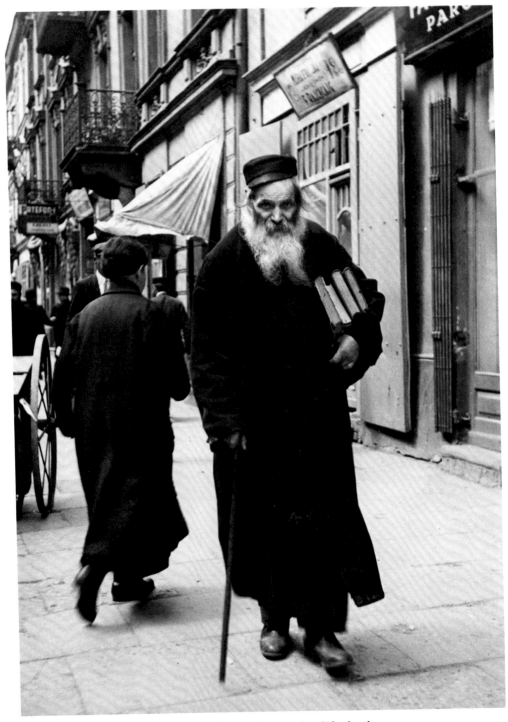

Jews are said to be the people of the book.
They carried books on the streets, and in their hearts. They
had books with them after they left this world.

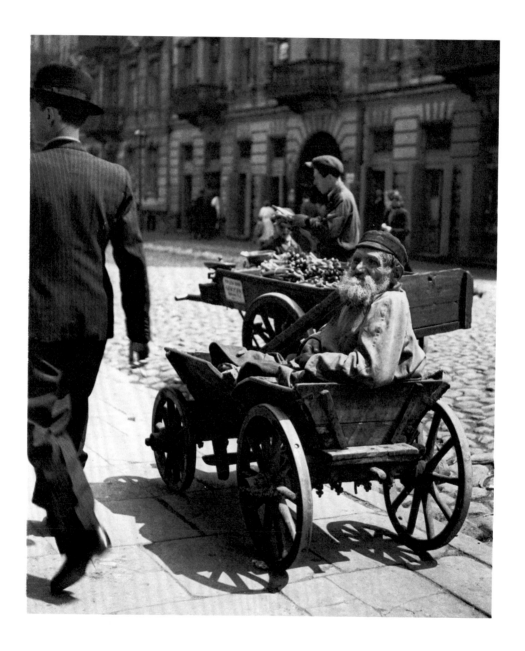

Warsaw

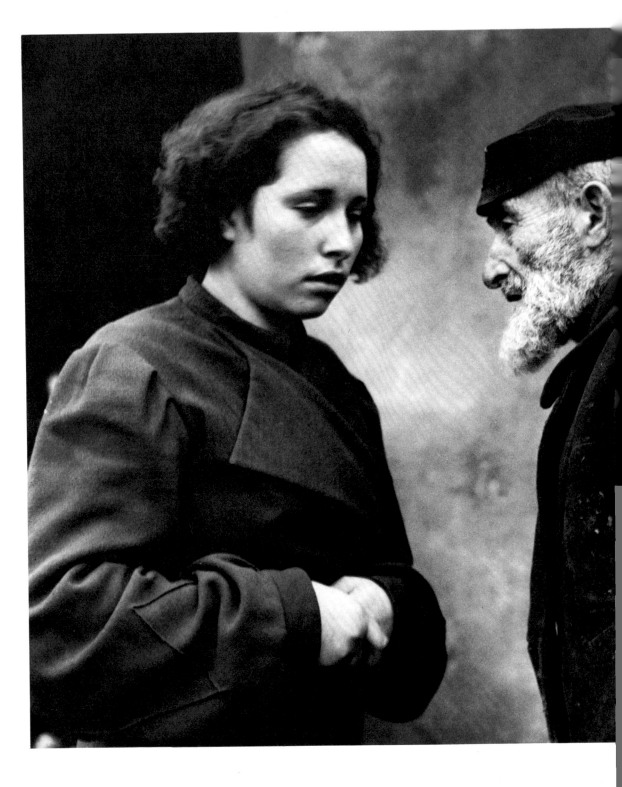

Lublin
A conversation between grandfather and granddaughter.
The man's hat is typical of Lublin and Warsaw.

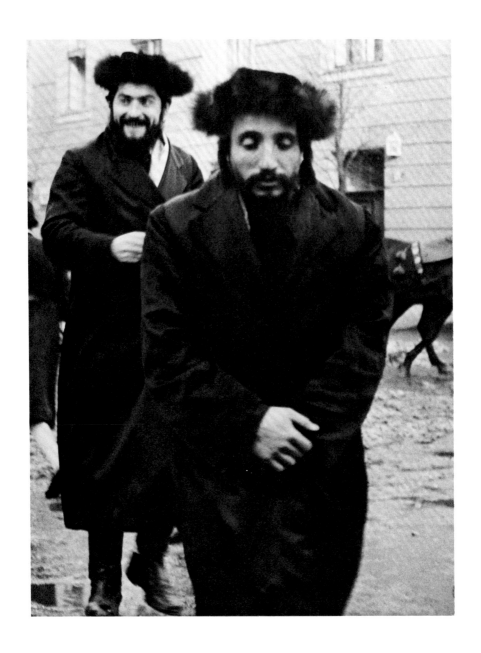

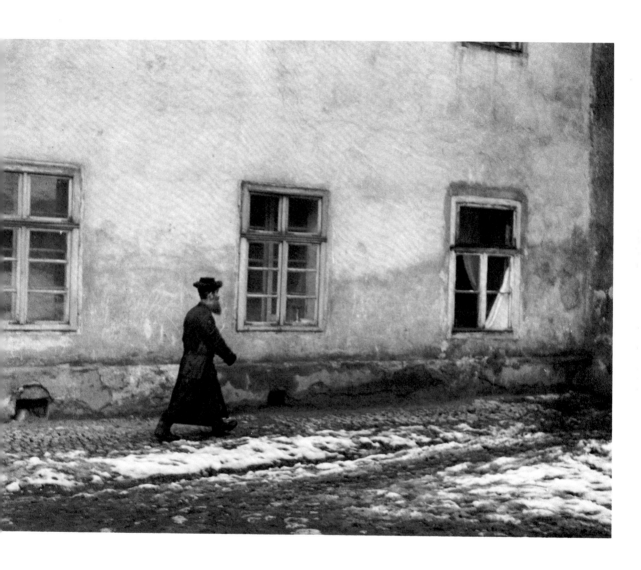

Street scene, Cracow

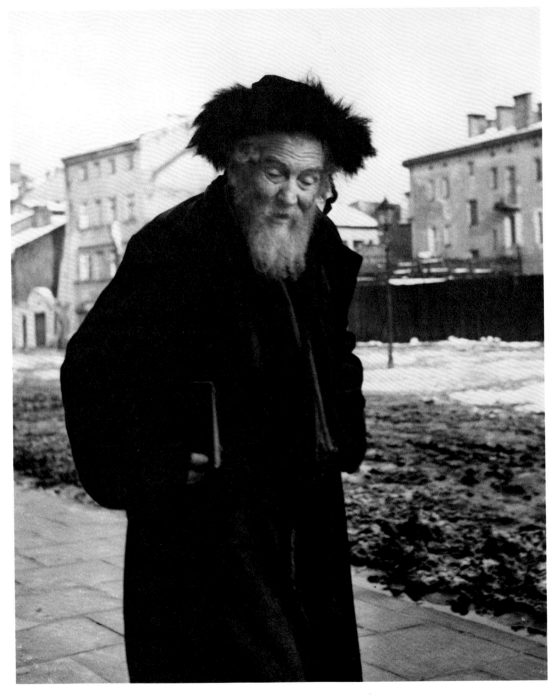

Cracow
Man wearing a *streimel*,
the hat worn by Hassidic
Jews on Sabbath.

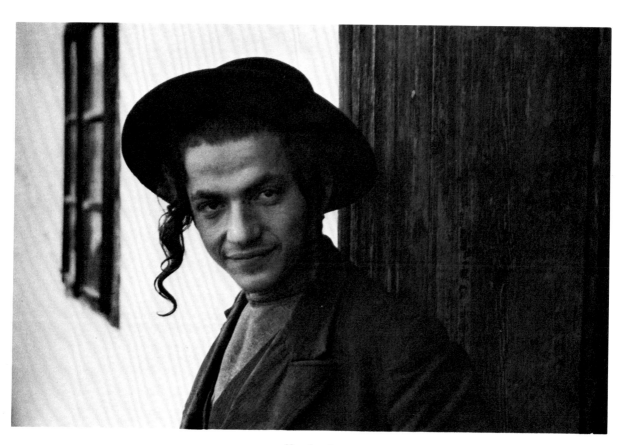

Verchovina

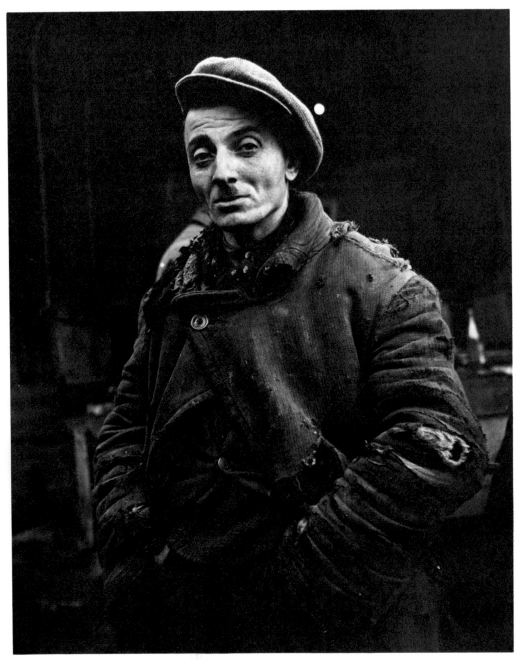

Warsaw

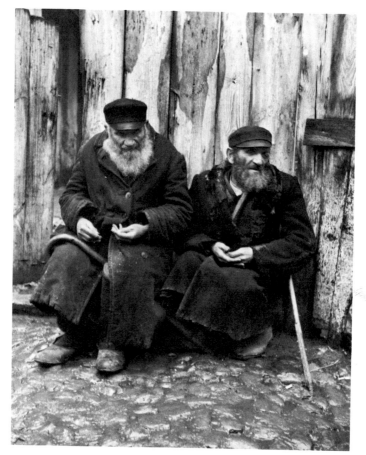

Lublin

The Rabbi of Munkacs
discussing the Talmud with his students. Hitler was told that this Rabbi spoke with God. Maybe he did, and maybe the Jews were liars, thought Hitler. Anyhow, the Rabbi was considered a holy man and was spared. In fact, today he lives in Israel.

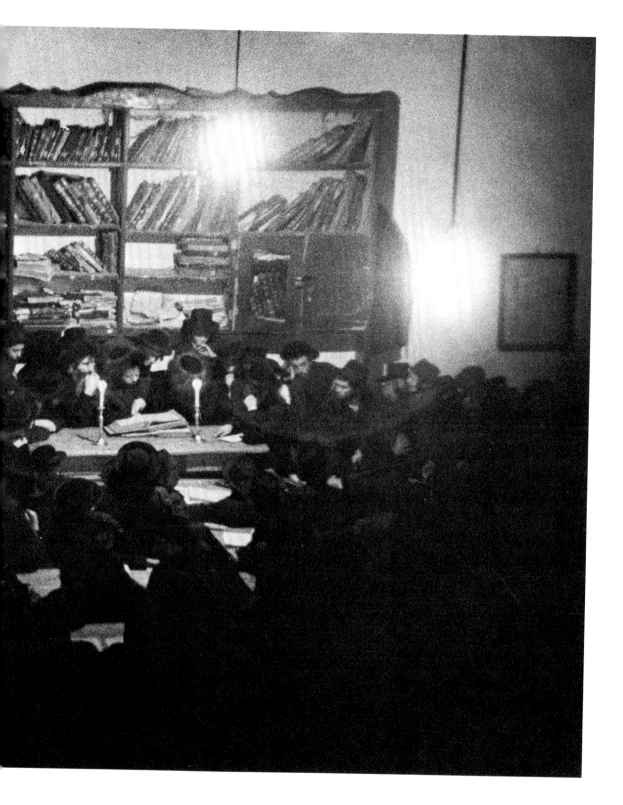

At night the time was free,
and people sat by candlelight and studied the Talmud. It was
very dark, but I wanted the pictures. They were not too good
technically, but they remind me, and will remind people
after me of what life was like forty years ago.

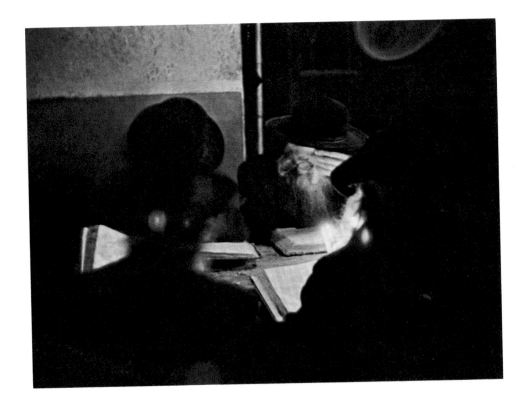

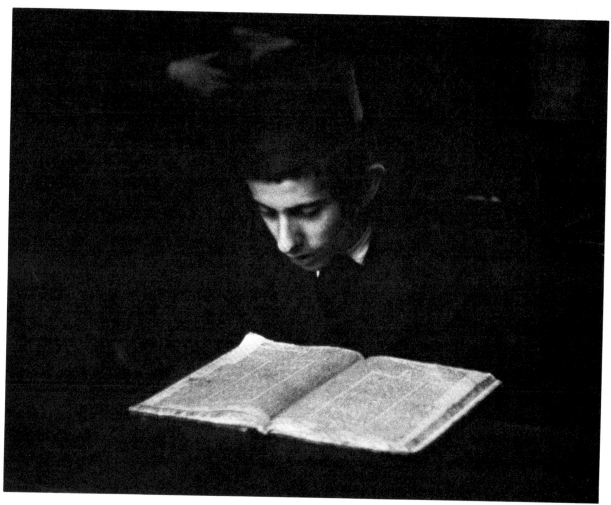

Yeshiva, Lublin

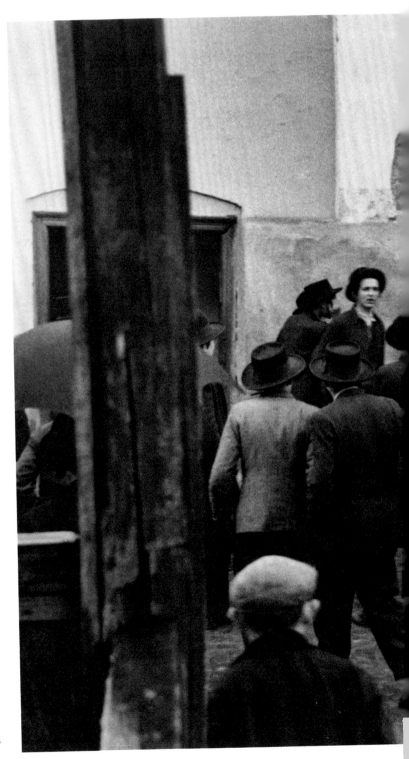

The Wonder Rabbi of Munkacs
with disciples

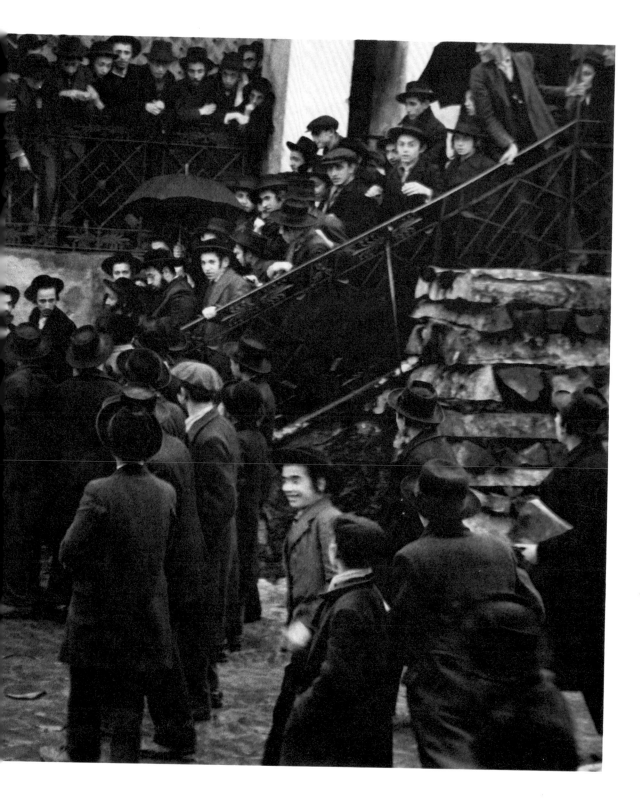

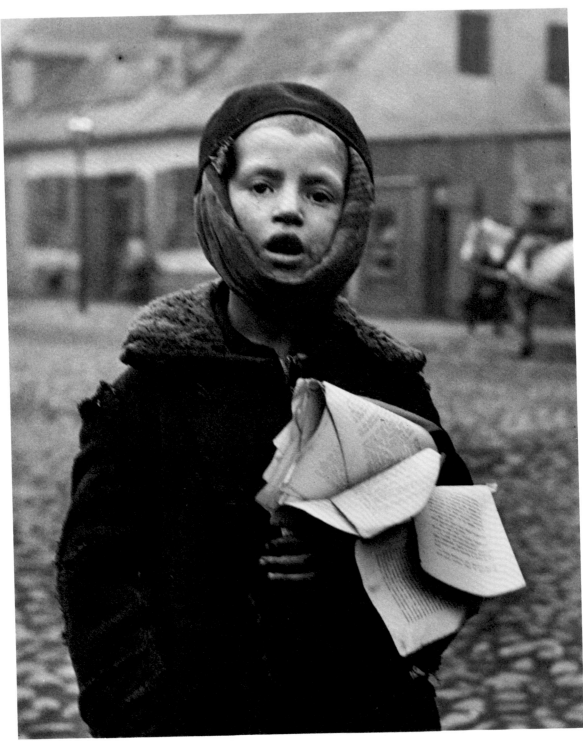

Lodz, Poland

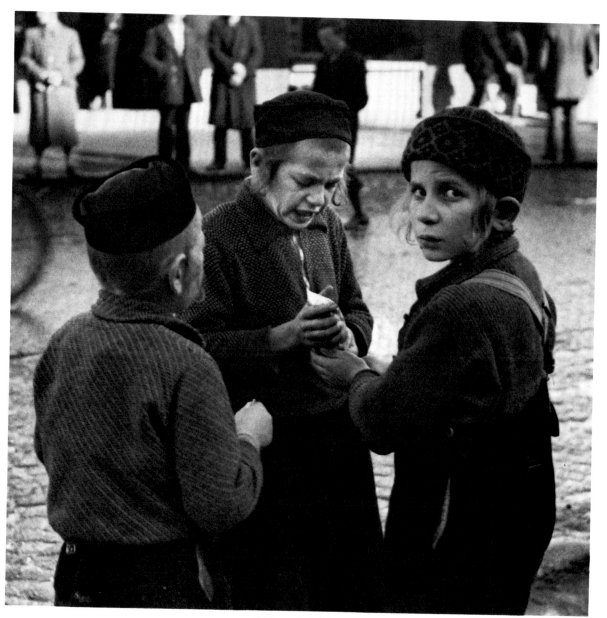

Uzhorod, USSR

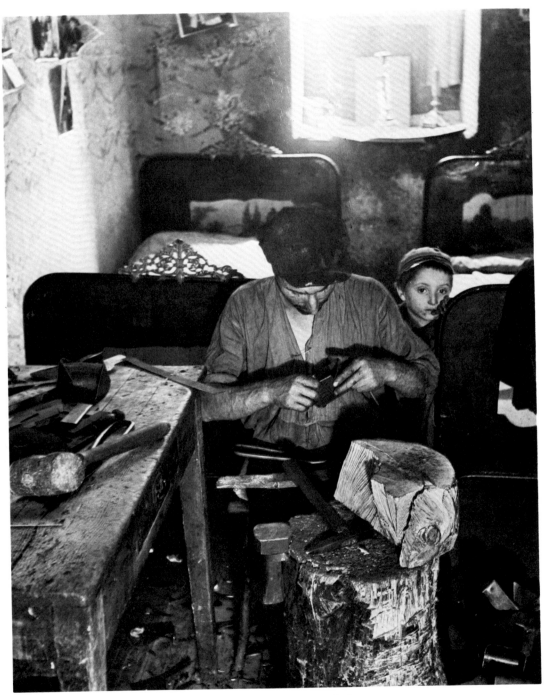

One-room apartment - workshop

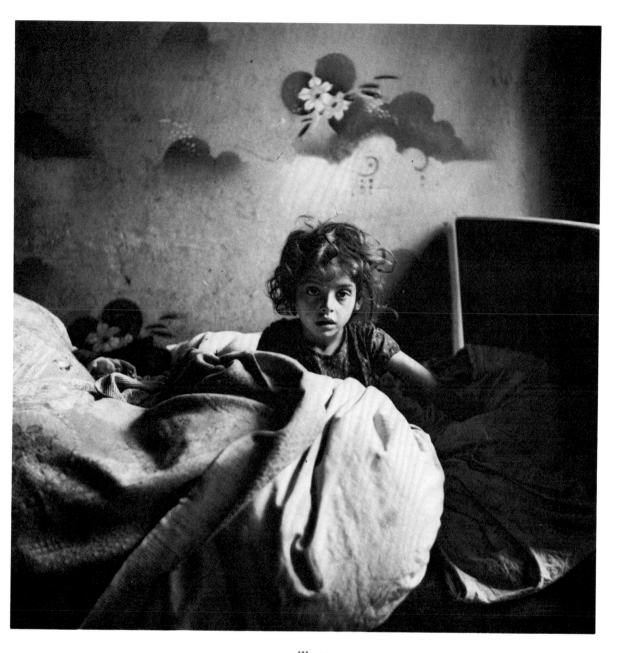

Warsaw
This pretty, sweet girl was very unhappy
because she had to spend the winter in bed. You see, it would have
been foolish to buy shoes for a little girl when the money could buy
food for the family, or shoes for those who could earn money. Her
considerate father painted flowers on the wall so that her winter in
bed would be pleasant. And these were the only flowers of her youth.

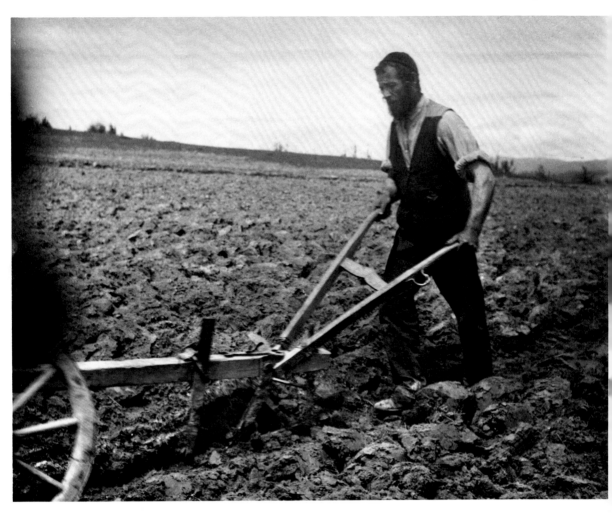

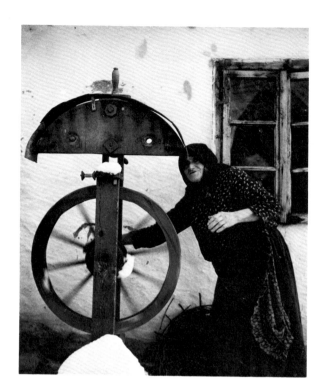

Spinning thread

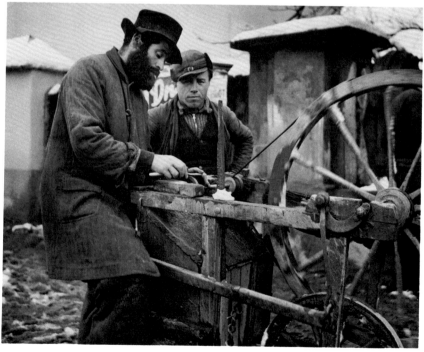

Scissors-grinder

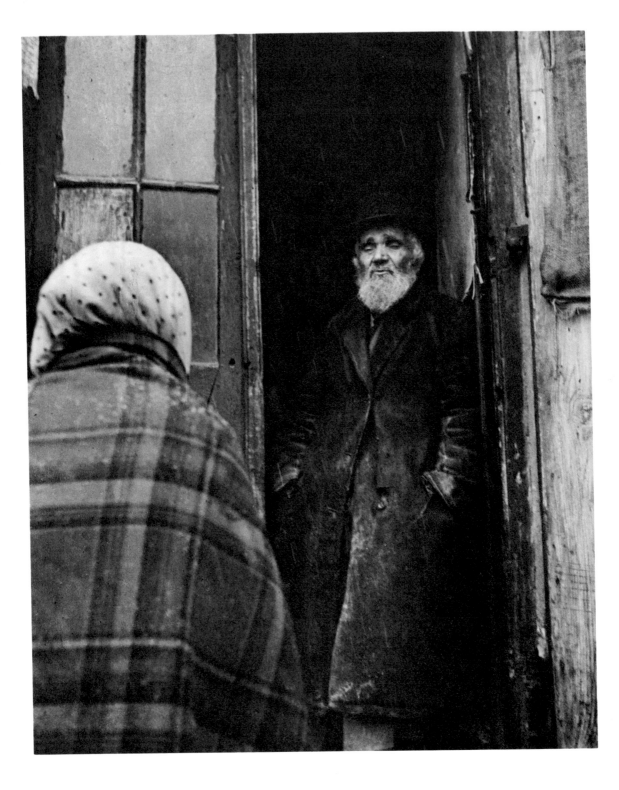

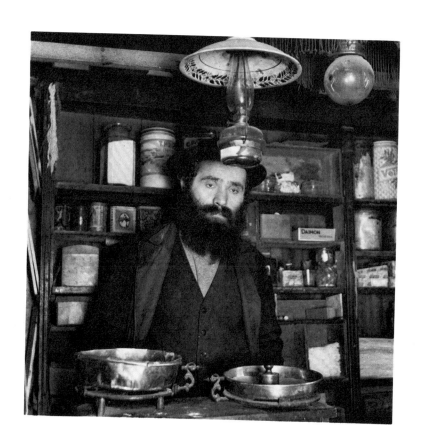

body came into the stores. Day after day . . . they had to pay their
␣t, they had to live. They could not do business. When finally a
␣wish customer came into the store, the owner said, "I have nothing
to sell."

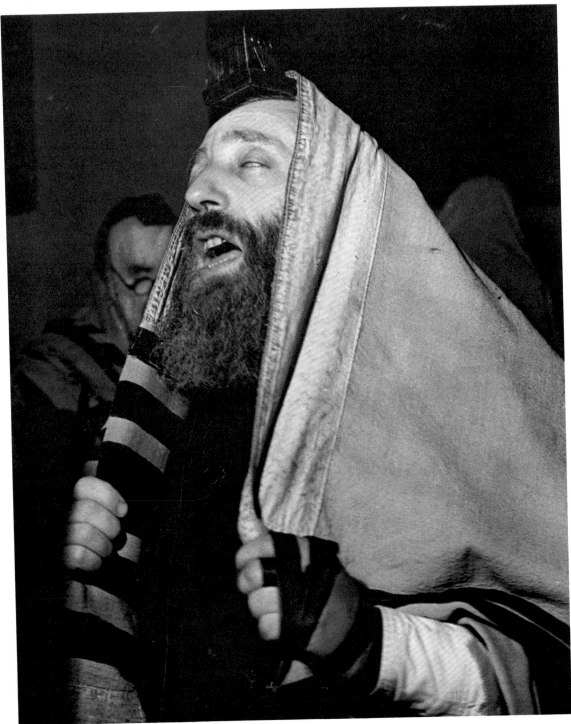

Germany, 1947

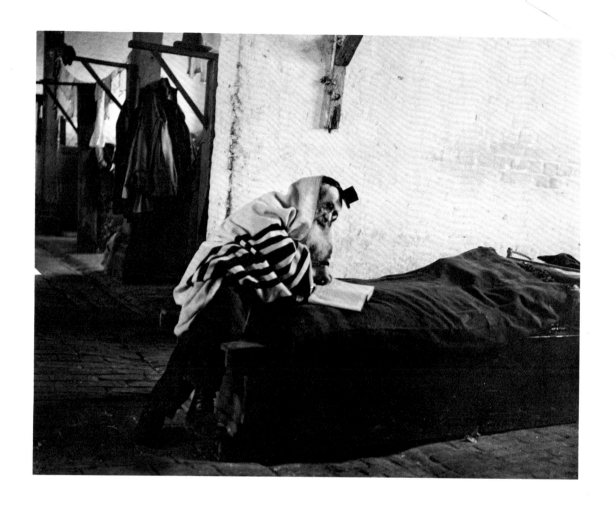

I photographed this man in a detention camp
while he said Kaddish for his dead wife and seven children. He was
with his family during the holocaust of the camps and the war, but
he was spared——by accident. People remained in this detention camp
until Israel became a salvation and home. Then, in 1948, with the
opening of Israel, the people left. Now the poor/happy man is in
Israel. That is the duty of life, I suppose, to remember the dead.

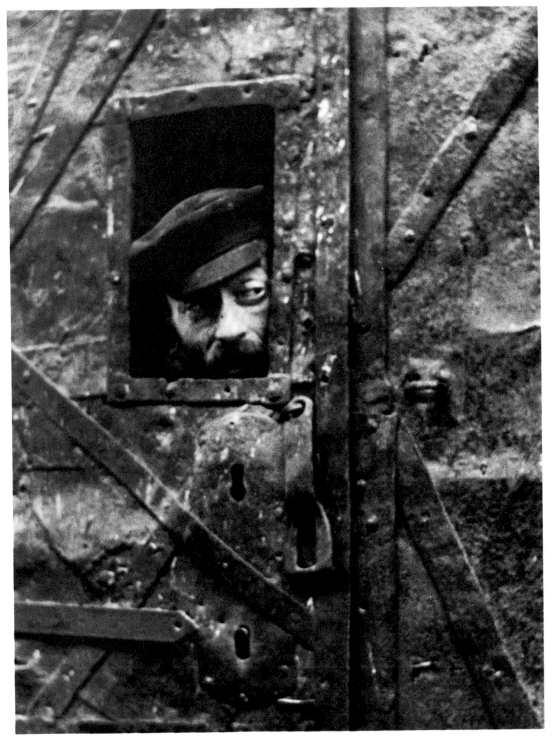

Warsaw

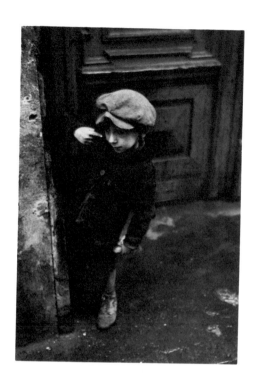

The active pogrom people were called *endekie*.
They went about in groups and made what the Germans called a
'crystal night' breaking windows and glass. Here in these poor
quarters there was no glass to break, so they could only break heads.
The little boy is signalling approaching danger to his father. But even
the iron door is no protection . . .

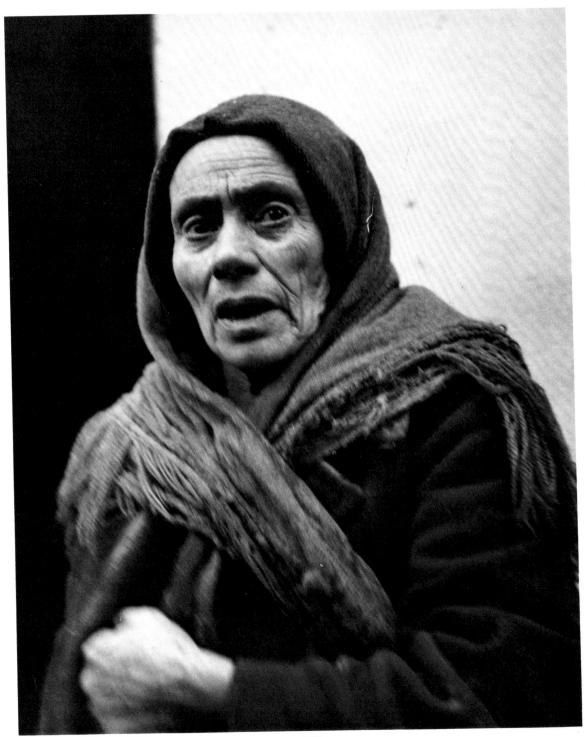

1937
A forty-two year old woman
searching for work in Lublin.

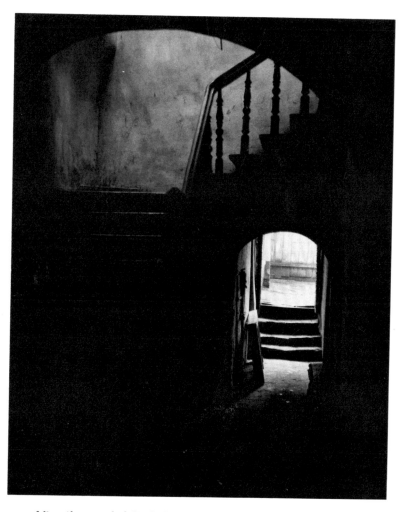

After the war I visited these places, looking for survivors. I only found five men whom I knew. One of them told me that the only thing left in him was the strength to say Kaddish. I had a biological thought: like ants or bees, many are destroyed, but some will survive. Something will survive. They did survive. Two years after the killing stopped, a new nation was born——Israel.

EXHIBITIONS

1939
One-man show,
The Louvre (Musée decoratif), Paris

1949
One-man show,
Teachers College, Columbia University

1962
One-man show,
"Through the Looking Glass,"
IBM Gallery, New York

1971
One-man show,
"The Concerns of Roman Vishniac,"
produced by The International Fund
for Concerned Photography, Inc.
Jewish Museum, New York

1972—1973
"The Concerns of Roman Vishniac,"
circulated by ICP: The Art Gallery of the
State University of New York at Albany;
The Corcoran Gallery of Art,
Washington, D.C.; New Jersey Public
Library, Fair Lawn; Kol Ami Museum,
Highland Park, Illinois; Skirball Museum,
Los Angeles, California; Judaica Museum,
Phoenix, Arizona

BOOKS

Polish Jews
New York: Schocken Books, 1947

Building Blocks of Life
New York: Charles Scribner's Sons, 1971

BOOKS ABOUT ROMAN VISHNIAC

*Spider, Egg and Microcosm:
Three Men and Three Worlds of Science*
(on Petrunkevitch, Romanoff, and
Vishniac), by Eugene Kinkead (New
York: Alfred A. Knopf, 1955)

The Concerned Photographer 2
on Davidson, Haas, Hamaya, McCullin,
Parks, Riboud, Smith, and Vishniac,
edited by Cornell Capa, text by
Michael Edelson New York: Grossman
Publishers in cooperation with ICP, 1972

SCIENTIFIC PAPERS

"The Chromosomes in Protozoa,"
Vestnik Biologii (Germany), August 1920

"The Microscopic Algae,"
Vestnik Biologii (Germany), April 1921

"A New Application of Polarization Optics
to Cytological Studies,"
Anatomical Record, November 1957

"A New Hypothesis on the Role of
Protozoa in Evolution,"
Anatomical Record, July 1958

"The Origin and Evolution of Life,
New Theory,"
Anatomical Record, November 1958

ARTICLES ABOUT ROMAN VISHNIAC

"New Methods and Techniques in
Microscopy of Roman Vishiniac,"
Life, December 17, 1950

"The Tiny Landscape," by Eugene Kinkead,
The New Yorker, July 2 and July 9, 1955

The New York Times, August 22, 1960

*American Men of Science:
The Physical and Biological Sciences*,
10th edition The Jacques Cattell Press, Inc.,
Arizona State University, 1961

The New York Times, March 22, 1962

The Washington Post, August 12, 1962

"Dr. Vishiniac and the Beauty of the Real,"
Kodak International Review,
Number 9, 1965—1966

"The Big Little World of
Dr. Roman Vishniac,"
Medical World News, December 9, 1966

Current Biography, February 1967

"The Concerns of Roman Vishniac,"
by Michael Edelson,
Infinity, October 1971

*The Concerns of Roman Vishniac:
Man, Nature and Science*
New York: The International Fund for
Concerned Photography, Inc. 1971

ARTICLES

1943
"All My Pictures Are Candid,"
Popular Photography, April

1950
"Myxamoeba of the Soil"
with Kenneth Raper, University of
Wisconsin,
Life, April 10

"New Ways to See Living Things,"
Life, December 17

1952
"Metamorphosis of Insects"
with Carroll M. Williams,
Harvard University,
Life, February 11

1953
"Plankton of the Sea," *Life*, November 20

1955
"Insects in Flight"
with Kenneth Roeder, Tufts University,
Life, August 8

FILMS

1949—1972
Living Biology Film Series,
produced under a grant from the
National Science Foundation:

"The Standing Water"

"Life in the Pond"

"The World of Many Habitats"

"The Rocky Shore"

"The Brim of Sand"

"The Edge of Sea"

"Microscopic Algae"

Encyclopaedia Britannica Films:

"Protozoa"

"Protophyta"

"Plankton"

"Reproduction"

"Life of the Sea Floor"

"Secrets of Life,"
Walt Disney Studios

"Microscopic Life in the Ocean,"
Oceanographic Institute

"Exploring the Hidden World,"
Warner Brothers—Pathé

"Aquatic Microcosms,"
Warner Brothers—Pathé

Horizons of Science Series,
Educational Testing Service of Princeton,
New Jersey:

"The Worlds of Dr. Vishniac"

"The Big Little World of
Roman Vishniac," NBC-TV

"The Concerns of Roman Vishniac,"
ABC-TV

MULTI-MEDIA PRESENTATIONS ABOUT ROMAN VISHNIAC

"Roman's Legions,"
designed and produced by Craig Fisher
and John Martin in cooperation with
ICP as part of "The Concerns of
Roman Vishniac" exhibition, 1971

"The Life that Disappeared:
The Vanished World of the Shtetl,"
narrated by Dr. Roman Vishniac,
edited by Sheila Turner, and produced by
the International Fund for Concerned
Photography, Inc., as part of
"The Concerns of Roman Vishniac"
exhibition, 1971

AWARDS

1952-1954
Best of Show: annual exhibitions of
New York Chapter of the Biological
Photographic Association

1956
American Society of Magazine
Photographers' Memorial Award for
"showing mankind the beauty of the
world it cannot see"

1959
Grand Prize, Art in Photography,
"Art in U.S.A.," New York Coliseum

GRANTS

1961-1964
National Science Foundation to produce Living Biology Film Series

HONORS

Former President:
New York Entomological Society

Fellow:
New York Academy of Sciences;
Royal Microscopic Society (Great Britain);
New York Microscopic Society;
Biological Photographic Association

Member:
American Society of Limnology and Oceanography;
American Society of Protozoologists;
National Association of Biology Teachers;
American Society for Biological Sciences;
American Association of University Professors

Board Member and Advisor on Science Films:
New York Film Council

U.S. Delegate:
International Science Film Congress

CHRONOLOGY

1897
Born, August 19, in Russia.

1905
Began photographing.

1906
Began experiments in photomicrography.

1914
Drafted into army.

1915-1920
Special research projects at Shanyavsky University: transformation of axolotl into ambystoma (19717); first time-lapse films in cinemicroscopy (1916-1918); morphology of chromosomes (1920).

1920
Received Ph.D. in Zoology from Shanyavsky Universtity and M.D. from Moscow University. Became Assistant Professor of Biology (Microbiology) at Shanyavsky University.
Left Russia for Germany.

1921-1939
Research in microbiology, endocrinology, and optics; doctoral studies in Oriental Art at the University of Berlin (although qualified to receive Ph.D., degree was withheld by the university on grounds of religion).

1933-1939
Filmed and photographed Jews of Eastern Europe.

1940
In Du Richard, a concentration camp in Annit, France.

1941
Arrived in the United States.

1941-1950
Established a portrait studio; continued work in photomicrography.

1950
Developed new hypothesis of the origin of life.

1950-1960
Developed principles of rationalistic philosophy.

1957
Appointed Research Associate at the Albert Einstein College of Medicine.

1960
Appointed Project Director of the Living Biology Series at Yeshiva University.

1961
Appointed Professor of Biology Education at Yeshiva University

1960-1972
Developed new methods in microscopy.

During the last five years, Dr. Roman Vishniac has delivered the following illustrated lectures on a diversity of subjects at various institutions of higher learning across the country:

ART
"The Living Frames of Renaissance Portraits"
"Creative Architecture from Marcus Vitruvius to Giambattista Piranesi"
"The Golden Age of Russian Painting"
"The *Avant garde* of Russian Painting"
"*Tsuba:* The Art of Japanese Sword Guards"
"*Nétsuké:* The Great Miniature Sculpture of Japan"

HUMANITIES
"The Road from Philosophy to Religion Through the Ages"
"Does God Exist? A Scientist's View"
"In Search of Life: Meaning of Truth"
"Philosophy of Independent Mind"
"Foundation of Modern Education" (presented at the UNESCO Conference, 1971)
"Occult and Astrology of the Old Times: Is It All Superstition?"
"The Laws of Nature as Preserved in the Middle Ages"
"Philosophy of Zen Revealed in Chinese Painting"
"Galileo: The Struggle for Modern Man's Freedom of Mind"

JUDAICA
"Sixteenth-Century Jewish Customs and Religious Ceremonies"
"The Vanished World of the Shtetl"
"The Shtetl: The Well-Spring of Modern Jewish Culture"
"Cabala"
"ORT and OZE in the Years Before the Second World War"
"Youth *Aliyah* in Hitler's Times"
"Medinas Yisroel"

NATURE
"The World of the Invisible"
"Nature of Ecology and Ecology of Nature"
"At the Frontier of Science and Art"
"Design by Nature"
"The World of Protozoa"
"Plankton: The Wanderers in the Sea"
"World of Insects"
"The Intimate Art: Structure of Plants"
"The Micro-Inhabitants of Rivers and Ocean Ready for Observation in Our Home"

NUMISMATICS
"The Twelve Caesars"
"Jewish History on Ancient Coins"
"Classical Art on Greek Coins"
"Jewish Medieval History on Coins in Renaissance and Baroque Manuscripts"
"Diagnosing Character and Disease of the Rulers of Antiquity Through Coin Portraiture"

PHOTOGRAPHY
"Living Portraiture"
"Master Photography" (presented as a part of The Concerned Photographer Program, New York University)
"The Classical Principles of Cinematography"
"Photomicroscopy"
"Cinemicroscopy"
"Animal Photography"
"Psychological Foundation of Photography"
"Witnessing Seventy Years of Photography: What We Won, What We Lost"

SCIENCE
"Romance of Microscopy"
"Origin of Life and the First Organisms" (a new theory, published in 1957)
"Evolution of Science: The Development of the Human Mind"
"Human Curiosity: The Road to Exploration and Research"
"Biology: The Open Gate to Healing of the Disturbed Mind, the Feeling of Insecurity, and Easy Learning"

FILMS
1921
"A Flower Opening," following his invention of time lapse photography in 1918

1925
"Viper's Bite"

1927
"Life in the Street: Berlin"

1933-1939
"Aliyah of Central and Western Europe," a document of the coming of Jews to the land of Israel as *olim* for permanent residence
"Activities of ORT-Obshchestvo Rasprostraneniya Truda stredi Yevreyev," Society for Manual and Agricultural Work in Poland, Germany, and France

MEDICAL FILMS
1937
"Metamorphoses of Amphibian Larvae" with human blood tests

1959
"Blood Circulation," with Dr. Philip Sawyer State University of New York, Brooklyn

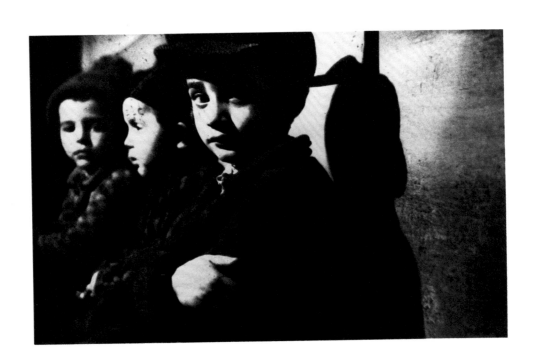